Images of Modern America

SOUTHWEST DC

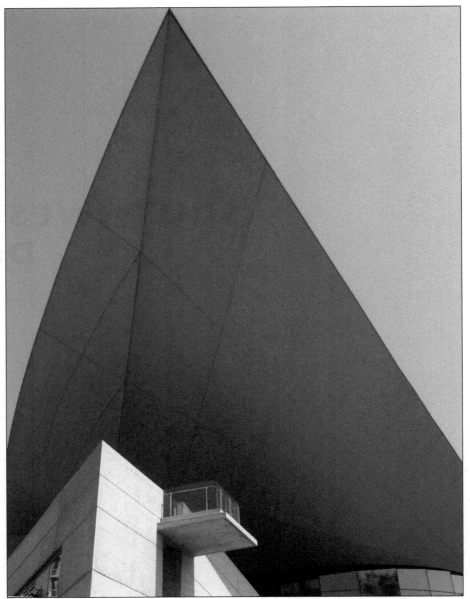

Arena Stage epitomizes the striking mid-century modern architecture seen throughout Southwest DC. (Authors' photograph.)

FRONT COVER: The Municipal Fish Market along the waterfront in Southwest DC (Library of Congress; see page 58)

UPPER BACK COVER: Harbour Square (Authors' photograph)

LOWER BACK COVER (from left to right): Christ United Methodist Church (Authors' photograph; see page 72), Dr. Dorothy Height at her callbox (photograph by Perry Klein/the *Southwester*; see page 77), Arena Stage (Authors' photograph; see page 67)

Images of Modern America

SOUTHWEST DC

PAUL K. WILLIAMS AND GREGORY J. ALEXANDER WITH
THE SOUTHWEST NEIGHBORHOOD ASSEMBLY

ARCADIA
PUBLISHING

Copyright © 2017 by Paul K. Williams and Gergory J. Alexander with the Southwest
 Neighborhood Assembly, Inc.
ISBN 9781540214461

Published by Arcadia Publishing
Charleston, South Carolina

Library of Congress Control Number: 2016953704

For all general information, please contact Arcadia Publishing:
Telephone 843-853-2070
Fax 843-853-0044
E-mail sales@arcadiapublishing.com
For customer service and orders:
Toll-Free 1-888-313-2665

Visit us on the Internet at www.arcadiapublishing.com

CONTENTS

ACKNOWLEDGMENTS

The authors would like to acknowledge that this book was commissioned by the Southwest Neighborhood Assembly, a nonprofit community organization formed in 1963 whose mission is to improve the quality of life of the residents of Southwest DC and to preserve its diverse history. The organization also publishes the *Southwester* newspaper, a source of several of our photographs. More information can be found at www.swna.org and www.thesouthwester.com.

Many thanks go to Mary R. Rankin of Perkins Eastman DC architects and the Gangplank Marina Slipholders Association for assistance in obtaining photographs. Other images were obtained from Perry Klein of the *Southwester*; the Library of Congress (LOC); the Washingtoniana Division of the Martin Luther King Jr. Library (MLK); the District Department of Transportation (DDOT); Populous/DC United; 3rd & M, LLC; National Capitol Planning Commission (NCPC); DC Department of Housing and Community Development (DHCD); Historical Society of Washington (HSW); PAWS of Southwest (Moody Graham); mapio.net; the Smithsonian Institution; the Wharf DC; Handel Architects; Mandarin Oriental Hotel Group; Eric Burka; Garland Gay; Diverse Markets Management; the US Holocaust Memorial Museum; and the National Cherry Blossom Festival.

INTRODUCTION

Modern Southwest DC's origins began in the 1950s and 1960s, when an unprecedented urban renewal project was undertaken to transform the struggling, often neglected quadrant in our nation's capital by demolishing thousands of existing homes, commercial structures, and other buildings in order to create a clean slate upon which to build. Although controversial at the time—and still debated heavily even today—the project did create an opportunity for Southwest to begin anew. The buildings constructed in the 1960s and 1970s were unlike anything Washington, DC, had seen before—mid-century modern architecture had taken hold in the United States, and the visionary architects who designed the new Southwest DC took advantage of the opportunity to leave their marks. The architects and landscape architects behind this effort are highly regarded still today—Chloethiel Woodard Smith, Morris Lapidus, I.M. Pei, Harry Weese, Haile and Liebman, and Cohen, Haft & Associates. Today, these historically significant designs play a large role in the reason why Southwest DC is seen as one of the more unusual planned communities found in the United States.

The architectural styles seen in the 1960s and 1970s are as varied as the demographics of those looking to relocate into Southwest DC. The massive residential projects—some extending eight to 10 blocks—were meticulously planned and took the unique approach of having high-rise apartment buildings coexist with low-rise townhome buildings and single-family homes. Despite the difference in size and style, most of the new residential projects created a harmonious feel and a sense of community. Large-scale apartment buildings combined with three-story homes also presented the opportunity for developers to attract homebuyers and renters from diverse socioeconomic backgrounds. This diverse lot of new residents was also drawn to the ample green space that was deliberately planned by developers and architects and the opportunity to live close to the waterfront—a rarity in Washington, DC.

Although Washington, DC, does not boast the iconic waterfront area seen in some of its metropolitan neighbors—Baltimore, Boston, and New York, for example—Southwest DC is home to one of the largest stretches of waterfront in the nation's capital, yet residents and tourists alike sometimes overlook this hidden jewel when visiting the nearby National Mall. A number of tour boat companies operate out of Southwest's waterfront area, offering the opportunity to see our nation's capital from a different perspective. In addition, Southwest is home to the East Coast's largest live-aboard boating community. Large yachts, sailboats, barges, and houseboats all provide ample living space for those fortunate enough to live on the water and take in sunset views on a nightly basis. Living aboard a boat is also one of the most economical ways to own a "home" in Washington, DC, and the tight-knit marina community provides a second family for many newcomers to the District.

The Southwest Waterfront is also home to the Municipal Fish Market, the oldest operating open-air fish market in the United States, and the new Anacostia Riverwalk Trail continues to introduce residents and tourists alike to Southwest DC. Like many parts of Washington, DC, the

waterfront area is the scene of endless construction projects, most notably the Wharf, a mixed-use project spanning the majority of the Southwest Waterfront.

Thanks to many commercial projects over the past few decades, those who live in Southwest are able to embrace the "live, work, play" lifestyle, as shops and restaurants are popping up all over the neighborhood, and the proximity to multiple federal buildings and offices translates into a short commute. The opening of the Southwest Waterfront Metro station also makes commuting and traveling throughout the District a breeze. The Metro also brings tourists to Southwest to attend theater performances at Arena Stage, visit one of the many Smithsonian museums in Southwest, pay their respects at the Martin Luther King Jr. Memorial, or expand their cultural horizons at the Hirshhorn Museum and Sculpture Garden.

The complete transformation that Washingtonians witnessed in the 1960s in Southwest was stunning; however, the current state of change the quadrant is undergoing rivals that time. It is impossible to walk through much of Southwest today without seeing large construction cranes. High-end condominium and apartment buildings seem to be sprouting up every week, many of them luring potential new residents with water views and upscale amenities. These new buildings not only feature much-desired interior features and finishes such as granite countertops, stainless steel appliances, and hardwood floors, but they also tout swimming pools, gyms, resident lounges with fireplaces, 24-hour front desks with concierge services, game rooms with pool tables, outdoor patios, and even dog washing boutiques.

One of the largest projects in Southwest—and the entire District, for that matter—is the Wharf, a multiuse project with 1,300 residential units, 960,000 square feet of office space, 358,000 square feet of retail space, over 600 hotel rooms, a 6,000-seat concert hall, a marina, underground parking, and 10 acres of open space. Southwest DC will also be the new home to DC United, the city's major-league soccer team, which will open a new stadium near Buzzard Point in 2018. The new stadium will introduce fans to a part of the District that may be new to them.

Throughout its history, Southwest DC has shown an uncanny ability, and willingness, to change its landscape, and there appears to be no immediate end in sight, as the neighborhood continues to transform itself, and in doing so, is creating one of the most exciting areas of Washington, DC.

One

EARLY REDEVELOPMENT PLANS

Many attempts had been made at improving the conditions of a deteriorating Southwest community long before the well-known systematic razing of the area that began in the 1950s. The Washington Sanitary Improvement Company had worked hard at raising funds and building adequate, affordable housing in the community as early as 1911, as it did in other neighborhoods of the nation's capital. It was one of the first such development corporations to target black working-class families in desperate need of affordable housing at the time. These efforts stemmed from the early documentation of the ill effects of alley life by Charles Weller and his wife, Eugenia, who both established Southwest programs to provide for the poor.

However, what Southwest is criticized by some and heralded by others for is the widespread urban renewal that called for the demolition of thousands of individually owned houses and buildings and the displacement of nearly 30,000 individuals in the 1950s and 1960s. They lost not only their homes and sense of community but also their livelihoods, as businesses and commercial structures were also demolished, along with most of their houses of worship.

What some saw as a travesty and worked hard to illuminate in other large cities as urban renewal policies took hold, others saw as an opportunity to rebuild a community on a clean slate, using modern materials and concepts to house a massive urban population in Washington. Private developers and land speculators also saw an economic boom for themselves on property reclaimed through eminent domain and available for well below market rates in exchange for a promise to build.

While there were both successful and unsuccessful results over time, the majority of residents moving to Southwest DC in the 1960s were those who were not displaced 10 years earlier. In any event, time has passed, and a new generation of preservation-minded individuals and residents alike have lauded the unique community and have had successful efforts to ensure that the structures of Southwest DC built in the 1950s and 1960s have been documented with historical significance and protected as part of one of the more unusual planned communities found in the United States.

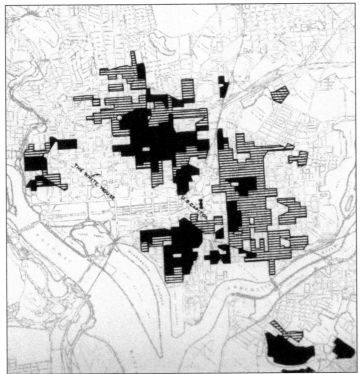

This 1950 map was delineated by the National Capital Park and Planning Commission and shows areas in black in which over 50 percent of the housing stock was estimated to need major repairs and lacked private baths. How the commission determined that was clearly subjective. The areas with cross-hatching were neighborhoods with "blighted characteristics." Most of Southwest fell into the two categories, and it was to be the focus of a major urban renewal process that called for the vast majority of the community to be relocated and the buildings systematically razed. (NCPC.)

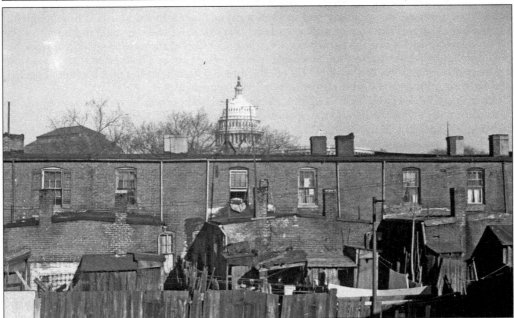

Images such as this one that show the proximity of a severely deteriorated neighborhood to the Capitol were used as propaganda by the Soviet government in the 1950s to illustrate the failure of capitalism. Ultimately, more than 30,000 people were relocated during the decades to come, as a massive urban renewal program was implemented. (LOC.)

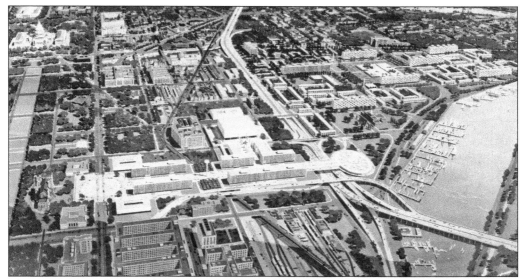

The extensive William Zeckendorf proposals for the redevelopment of Southwest can be seen in this aerial conceptual drawing from 1955. It was conceived by the New York developer between 1954 and 1959 in an area called "Project C." Zeckendorf envisioned entrance to Southwest via a Tenth Street Mall and housing for 4,000 families of various income levels. His New York–based real estate empire crashed, however, before plans could be realized. (NCPC.)

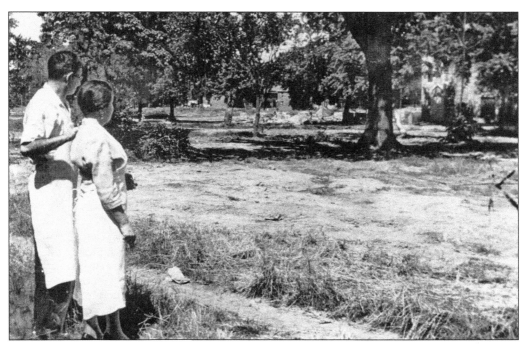

Multicultural residents were displaced in the urban renewal efforts of Southwest. Here, Mrs. Ezra Lazer and her brother-in-law Samuel Holstein are posed by a *Washington Star* photographer in June 1956 looking at vacant land that once was occupied by patrons of their grocery store. (MLK.)

Bernard Green is seen in 1957 posing in front of his liquor business at 624 Fourth Street, once the center of a vibrant Jewish-owned business center. His was the last store open on the block before it was razed for redevelopment. (MLK.)

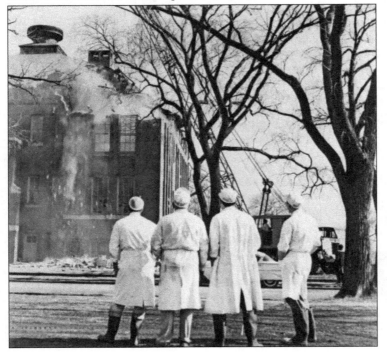

With most of old Southwest already cleared, these uniformed employees of the Briggs Sausage Company watch as the Fairbrother Elementary School is razed on February 3, 1960. (DHCD.)

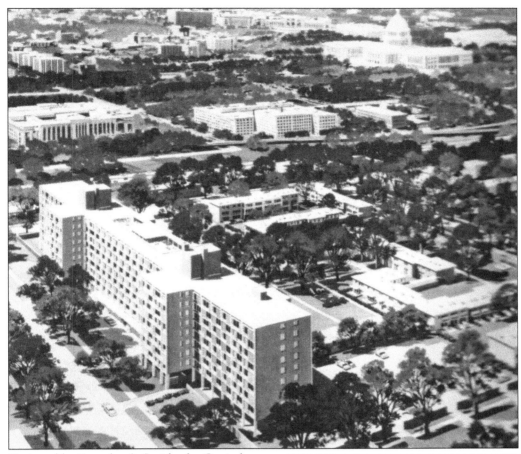

Designed by Satterlee & Smith, the Capitol Park (Potomac Place) replaced the Dixon Court, often used as an example of the blighted neighborhood without regard to the human element and family orientation of a long-established community. (MLK.)

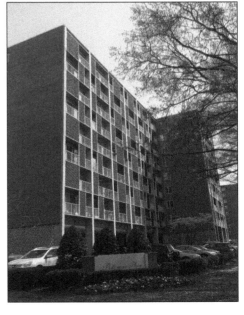

The completed vast complex known today as Potomac Place was built in 1958 at 800 Fourth Street. As the first mid-century modern urban renewal structure in Washington, it is noted as being the first building to have a full-glass first-floor lobby, which led to an exception to the city's height regulations. President Eisenhower took a particular interest in the building, showing it to Soviet premier Nikita Khrushchev as an example of the latest in urban living. (Authors' photograph.)

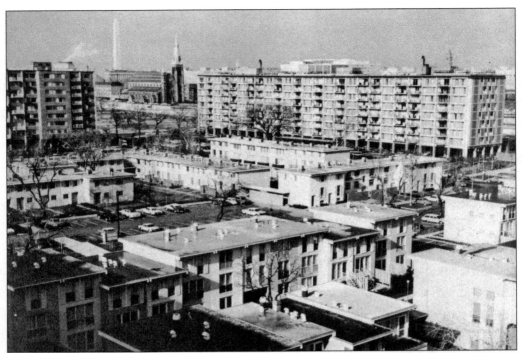

The enormous and ambitious Capitol Park development is seen here. The 3.1-acre site known as Subpart B of the Southwest Redevelopment Plan of 1952 was the largest residential complex in Southwest. Its innovative design, combining low-rise and high-rise buildings in addition to a series of parks and courtyards, was seen as a nationwide model of urban redevelopment. (DHCD.)

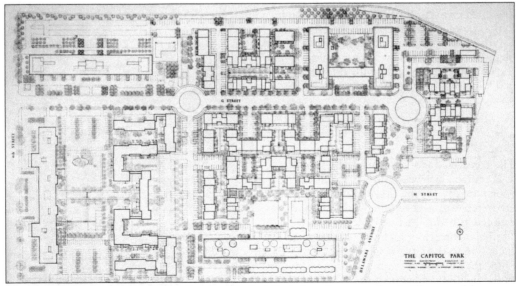

The extensive landscaping plan for the Capitol Park housing complex is illustrated here, an entirely new plan possible because of the cleared and vacant land. (LOC.)

14

The principal in the architectural firm of Satterlee & Smith, Chloethiel Woodard Smith, was a woman who had the vision to redesign an entire community on recently vacated land. She is responsible for much of what is visible in Southwest today, including the Capitol Park complex on Fourth Street, known today as Potomac Place. Critics applauded her design, the first development in the community that featured such innovative elements as outdoor fire pits and interior folding walls that separated bedroom areas in the efficiency units. Below, Smith stands with the model of Capitol Park. (Right, MLK; below, LOC.)

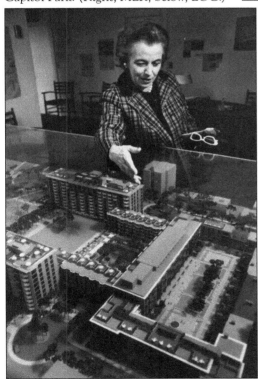

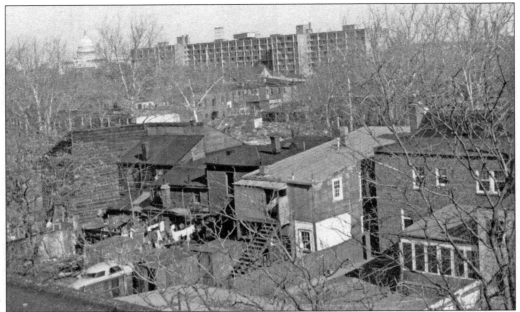

Not all of the Southwest neighborhood was razed at one time, as many people believe. Instead, it was a process that took more than a decade, often with new high-rises coexisting along with century-old housing stock, as seen in this c. 1960 photograph. The Capitol Park high-rise is seen in the background. (MLK.)

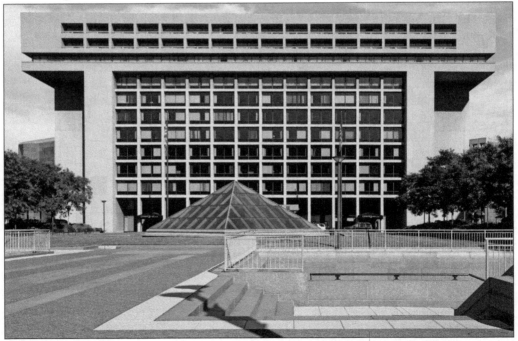

The L'Enfant Plaza complex is perhaps better known for its Metro station than the once-grand office complex, hotel, and promenade that was first envisioned by the architectural firm I.M. Pei & Associates when building began in 1965. (Authors' photograph.)

The Daniel Urban Kiley landscape firm designed the mostly concrete Tenth Street promenade in 1968, and the hotel and west office complex, designed by Vlastimil Koubek, was opened in 1973. To the left are the Astral building and Comsat building, both of which were designed by Araldo A. Cossutta, of I.M. Pei & Associates, in 1968. (Authors' photograph.)

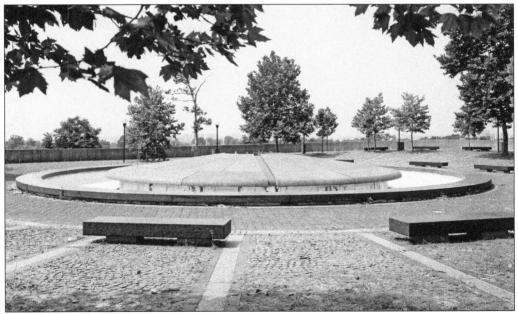

An outgrowth of the Zeckendorf-Pei plan for Southwest, the Tenth Street promenade that was envisioned was unfortunately terminated with a fountain in 1968 at the Banneker overlook due to the exit ramp for I-395, and it remains an anomaly of urban vision from the 1960s. It was designed by Dan Urban Kiley. Southwest residents and tourists headed to the Metro station from the waterfront continued to scale a non-landscaped hill on a dirt path from the popular Maine Avenue waterfront almost 50 years later. (MLK.)

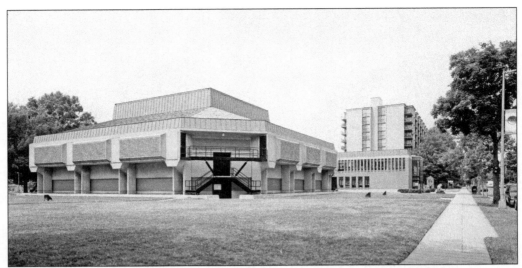

The original configuration of the Arena Stage building at Sixth and M Streets was built in 1961 and was designed by Harry Weese & Associates, who were also the designers of Washington's Metro system. Started earlier in Northwest DC, Arena went against local practice and policies by insisting on an integrated audience beginning in 1951; it had been founded by Zelda Fichandler the year previous. In 1967, the Arena Stage play *The Great White Hope* won a Pulitzer Prize and launched the career of James Earl Jones. The Kreeger Theater was added in 1970, also designed by Weese & Associates. (LOC.)

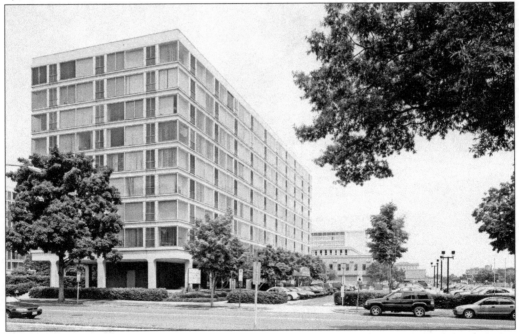

The Marina View Towers South (originally Town Center Plaza West) at 1000–1100 Sixth Street was originally built between 1961 and 1962 to the designs of well-known architect I.M. Pei as an apartment complex. Chloethiel Woodard Smith designed a larger commercial complex at the site in 1972. (LOC.)

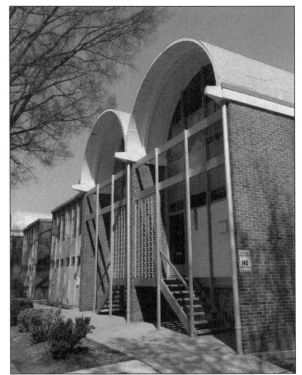

The River Park complex began construction in 1962 and opened as a cooperative apartment complex the following year, with a range of high-rise tower units and low-rise townhouses characterized by their distinctive barrel-vault roofs. When the complex opened, its tenants worked to ensure a diverse population purchased its units. It is located between Delaware Avenue and Fourth Street. (Both, authors' photographs.)

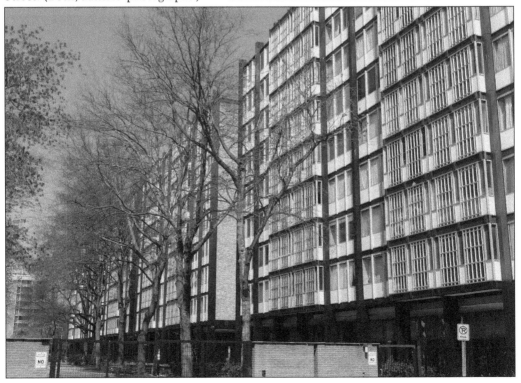

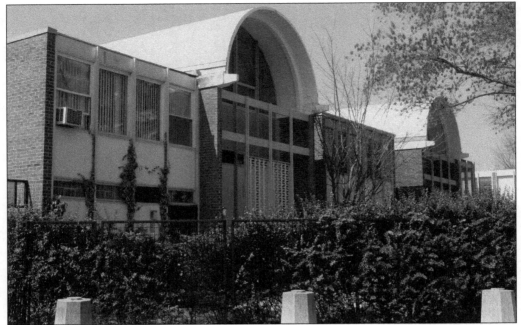

The River Park complex was designed by architect Charles M. Goodman, who utilized aluminum from the Reynolds Metals company on its facade design in what was one of the more unusual characteristics of the cooperative. Like many others in the neighborhood, the complex was designed with both highly desired townhouses for families and large-scale high-rise buildings. (LOC.)

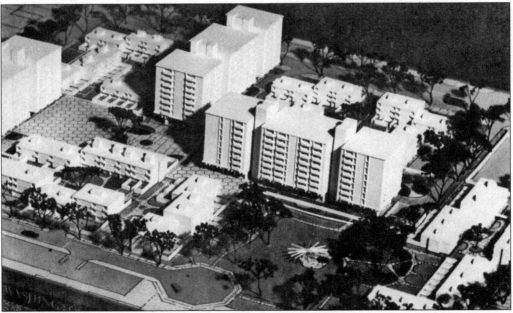

The model for the Carrollsburg Square Development is pictured here in 1965. It shows plans that call for spacious open green areas and paved plazas, without a car in sight as designed by the architectural firm of Keyes, Lethbridge & Condon. The firm had won a design competition held by the developer of the site, Charles H. Tomkins. (DHCD.)

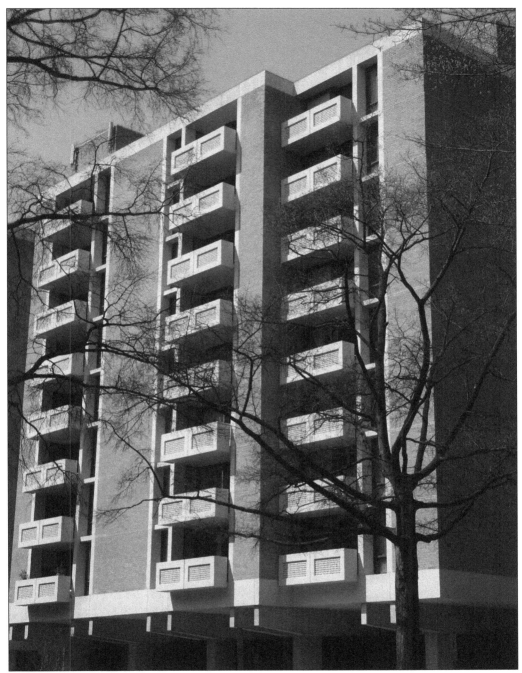

The Tiber Island cooperative complex was built in 1965 at 429 N Street and incorporated the c. 1794 Thomas Law House into its design. The house, at 1252 Sixth Street, was leased in 1796 by Thomas Law, who lost a fortune made in India by speculating on Washington real estate; his bride was Eliza Parke Custis, granddaughter of Martha Washington. The house served as a hotel in the 1860s. The Tiber Island complex was designed by the architectural firm of Keyes, Lethbridge & Condon. (LOC.)

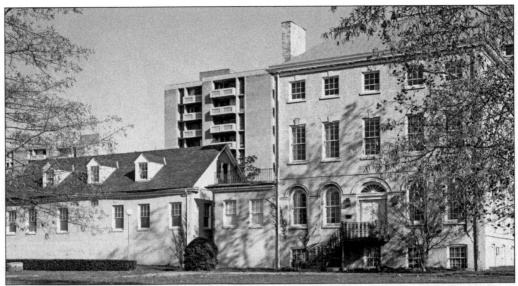

Upon completion in 1965, Tiber Island was awarded two individual prizes in the Redevelopment Land Agency competitions. The combination of apartment towers and townhomes surrounding a covered central plaza was innovative for the time. (Authors' photograph.)

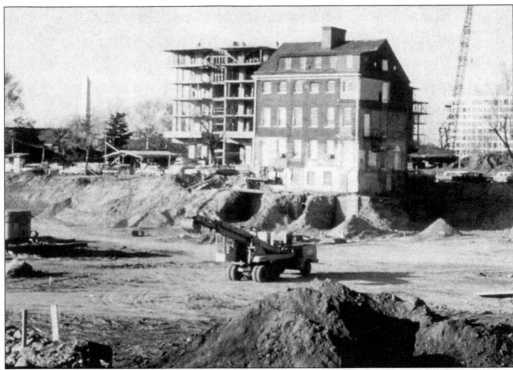

The c. 1794 Duncanson-Cranch House is seen here while undergoing extensive renovations as part of its inclusion into the Harbour Square complex in 1963. Note the extensive foundation walls uncovered that once supported additional buildings on the site. (HSW.)

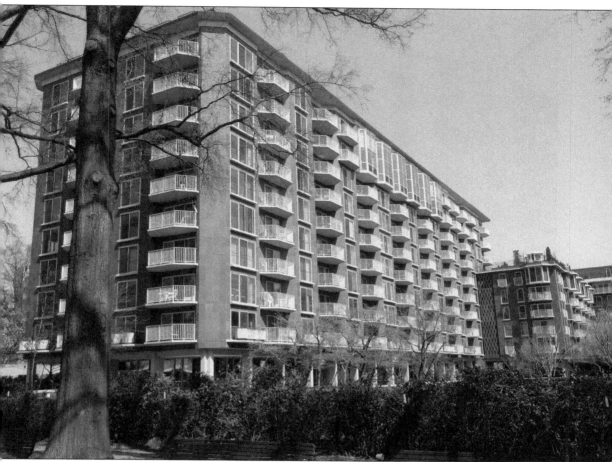

The Harbour Square complex was built with an impressive 443 individual units with 127 different floor plans. Most units have spectacular views of the waterfront or the National Mall. This complex, considered by some architectural historians to be the most important of the Southwest urban renewal residences because of its innovative design, was designed by architect Chloethiel Woodard Smith. She arranged eight adjoined buildings of varying design around three quadrangles. Perhaps the most distinguished element is a one-acre reflecting pool, which covers a 500-space indoor parking garage. Because of the remarkable variety of sizes of units—some of which have private roof gardens—the complex has housed residents with diverse backgrounds, including dozens of senators, congressmen, judges, and generals. (Authors' photograph.)

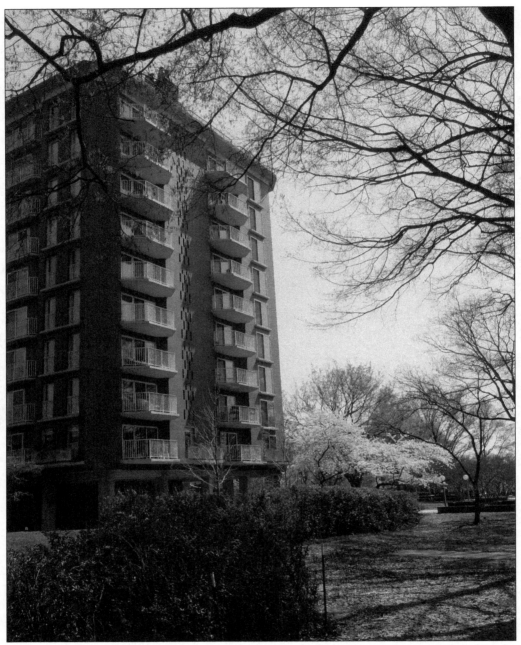

Harbour Square, noted for its incorporation of a group of historic townhouses, is listed in the National Register of Historic Places. Since the 1960s, numerous prominent Washingtonians have called Harbour Square home. Harbour Square's most noted early residents were Vice Pres. Hubert H. Humphrey and his wife, Muriel, who moved here in October 1966. According to news reports, during the 1968 presidential campaign Humphrey told friends that, if elected, he and his wife had no intention of moving out of Harbour Square to live in the White House. Landscape architect Daniel Urban Kiley created Harbour Square's open spaces, sunken gardens, aquatic garden, and landscape of varied trees, including sugar maples and willows. (Authors' photograph.)

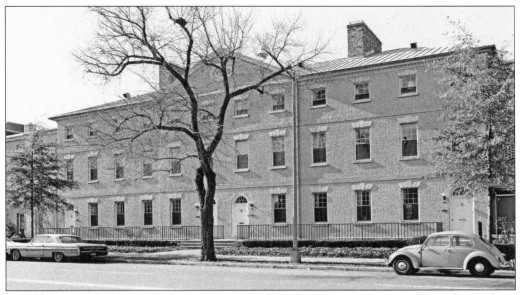

The four houses built in 1795 that constituted Wheat Row were incorporated into the Harbour Square complex as the development's largest co-op townhouse units. They retain much of their interior architectural elements, and today their lower levels open directly inside of a modern parking garage. (LOC.)

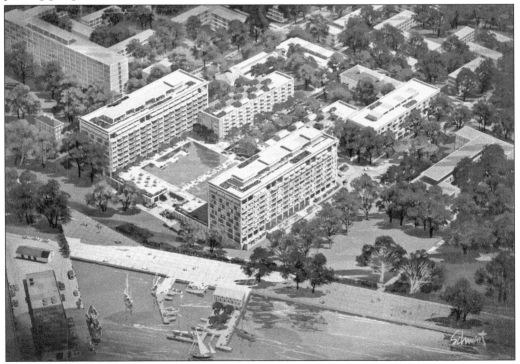

The enormity of the Harbour Square complex can be seen in this bird's-eye view drawn for various public meetings before the complex was built. Its courtyards feature large reflecting pools and fountains. (LOC.)

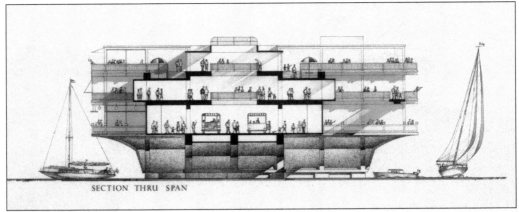

SECTION THRU SPAN

This cross section of a proposed multilayered bridge was drawn in 1966 by architect Chloethiel Woodard Smith to connect Southwest to the East Potomac Park, also known as Hains Point. It included a tunnel for buses, and rental income from shops along its exterior was planned to pay for the bridge itself. The ambitious design was never realized. (LOC.)

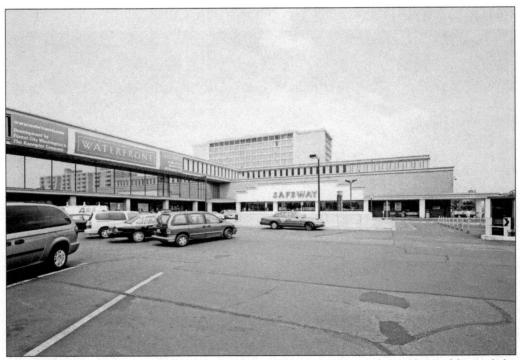

The Waterside Mall was built to replace the 4 1/2 Street commercial corridor and housed the US Environmental Protection Agency, a grocery store, and small stores and restaurants. It was designed by Chloethiel Woodard Smith & Associates and built in 1972. The Metro station was later constructed underneath the building, which was subsequently razed and replaced with a new series of plazas and buildings in the early 2010s. (LOC.)

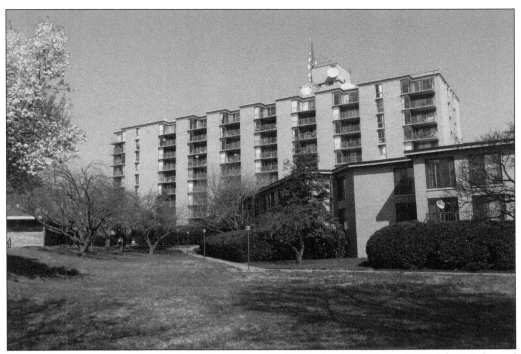

Waterside Towers was also designed by Chloethiel Woodard Smith in 1970. The U-shaped apartment complex faces an interior courtyard with a few townhomes and is located at 905–947 Sixth Street. (Authors' photograph.)

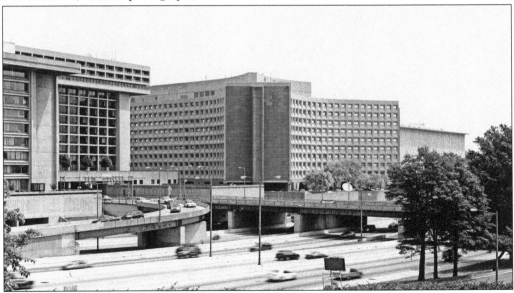

This view looks northeast from the Banneker overlook across the freeway to the Housing and Urban Development (HUD) building, L'Enfant Plaza Hotel, and former Comsat building. The HUD building at 451 Seventh Street, also known as the Robert C. Weaver Federal Building, was designed by Marcel Breuer and completed in 1968. The hotel was designed by Vlastimil Koubek and opened in 1973. (LOC.)

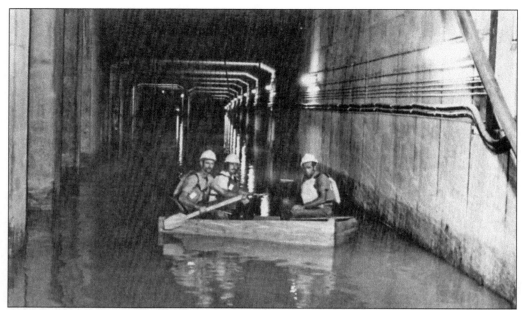

During Metro construction in August 1977, a delay in connecting the Green and Yellow Line tunnels just south of L'Enfant Plaza to their raised bridge counterparts left them vulnerable to flooding, which is exactly what happed on August 25. The water flowed downhill to a low point at Federal Center and rose to a height of four feet, seen here. (Photograph by Paul Myatt, MLK.)

This general view along the waterfront shows one of the five waterside parks designed by Sasaki, Dawson & Demay between 1968 and 1972. (LOC.)

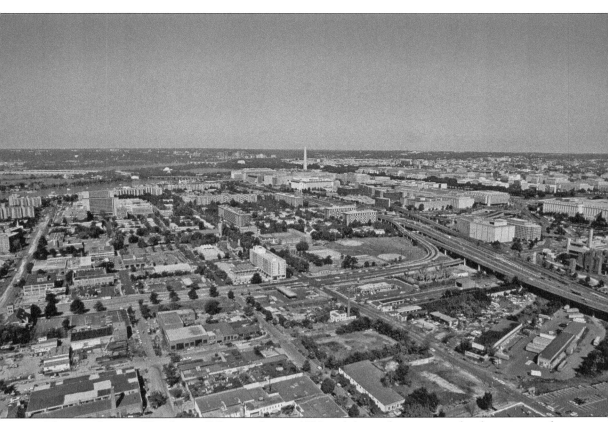

This aerial view of Southwest DC was taken in 1980 and shows the vast area that has witnessed the most dramatic changes in real estate development in the city. The confluence of historic churches next to modern office and apartment buildings is one of the rather unusual aspects of such change. (LOC.)

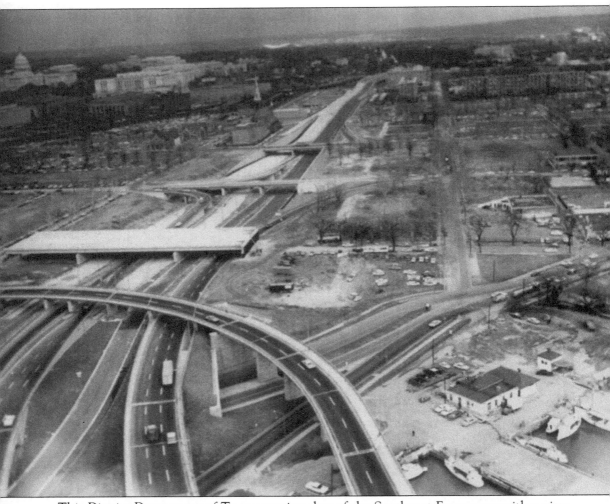

This District Department of Transportation shot of the Southwest Expressway with a view looking east from Twelfth Street SW in 1970 illustrates the vast changes coming to Southwest DC. (DDOT.)

Two

RESIDENTIAL EXPANSION

Perhaps nowhere else in the city of Washington, DC, is a more varied type of housing found than in the Southwest neighborhood. What may seem like random blocks of varying architecture, both large and small apartment towers and townhouses, were actually designed together as enormous complexes with diverse housing for all income levels, often extending up to 10 square blocks. Projects built in phases, such as the Capitol Park complex, included more than 1,000 apartment units in multiple towers along with hundreds of two- and three-story townhouses. The wide variety of housing was meant to attract a diverse socioeconomic community with offerings from a small studio apartment to a four- or five-bedroom house with ample parking. The scale of urban renewal that took place in Washington, DC, in the 1950s and 1960s had never been seen in the country, and other cities were eagerly taking note.

The architects and landscape architects behind this renewal effort were an impressive array of individuals that included Chloethiel Woodard Smith; Morris Lapidus; I.M. Pei; Harry Weese; Haile and Liebman; and Cohen, Haft & Associates. Residents have been proud to point out many of their works for several decades, and many choose to relocate here because of the rarity of living in a master architect's work so close to downtown Washington. Several of the complexes have now been recognized and protected as city and national landmarks and included in the National Register of Historic Places.

Yet with all this building, the Southwest neighborhood also retains vast amounts of open green space for recreation. Today adjacent to multiple marinas and several shopping and dining strips with a tremendous amount of building activity and expansions, the Southwest neighborhood is emerging as one of the most desirable places to live and work in the city.

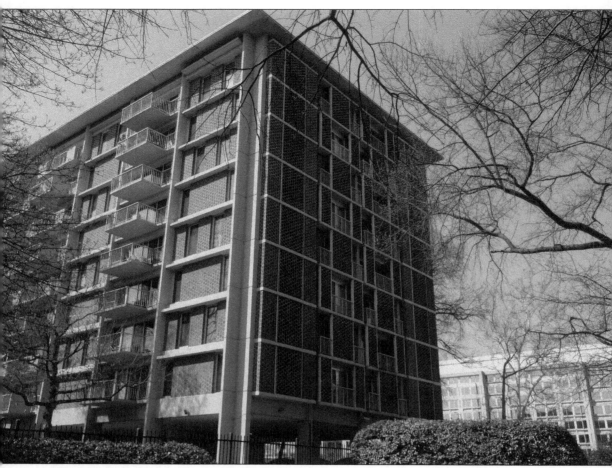

Capitol Park Towers was designed by Washington architectural firm Chloethiel Smith & Associates and developed as the first racially integrated project in a Southern city. The complex includes five high-rise towers that feature brick or terra-cotta latticework. Tower units have individual balconies featuring detailed tile screens. Renowned landscape architect Daniel Urban Kiley created a landscape that was an integral element of the parklike housing complex. Tower lobby entrances and townhouse corridors were carefully designed to unite the interior and exterior. Although built in stages, the complex was designed as a unified whole and won several awards for its parklike atmosphere. (Authors' photograph.)

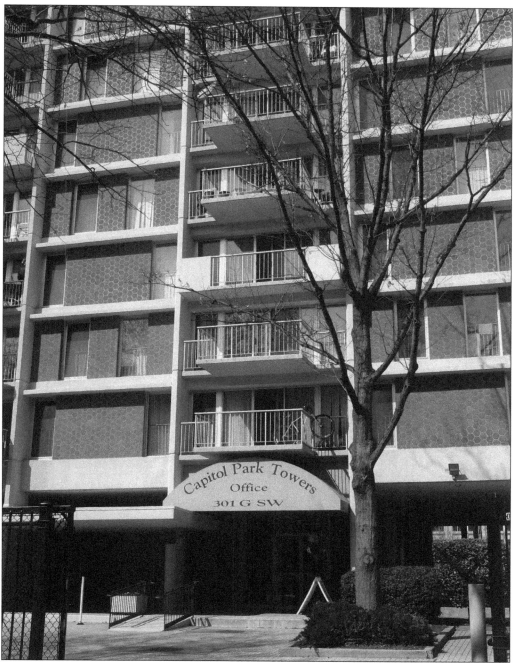

While retaining its historical integrity, Capitol Park Towers has adapted to changing lifestyle trends and what residents desire over the years. It now offers over 20 unique floor plans for studio, one-bedroom, and two-bedroom units. Capitol Park Tower's interiors have been fully renovated to include floor-to-ceiling windows, large closets, stainless steel kitchen appliances, new cabinetry, hardwood flooring, and more. A swimming pool makes this historical gem very attractive to residents of all ages. (Authors' photograph.)

Capitol Park Towers residents have easy access to the Anacostia Riverwalk Trail and stunning water views. The ample benches and green areas allow for peaceful reflection and a quiet end to a hectic day. (Authors' photograph.)

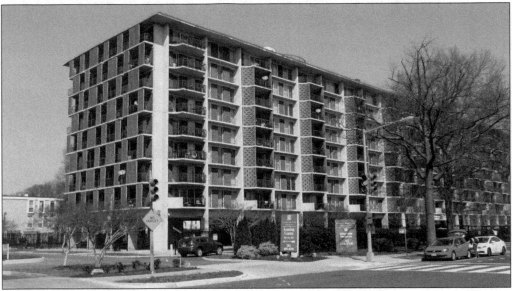

Capitol Park Plaza, at 201 I Street SW, was part of the original Capitol Park complex and has 616 apartment units split among three towers, an on-site fitness center, and a pool. The apartments are designed for the maximum amount of natural light, and most have balconies. Every apartment comes with a generous amount of closet space, new kitchen cabinets, insulated windows, and parquet floors. (Authors' photograph.)

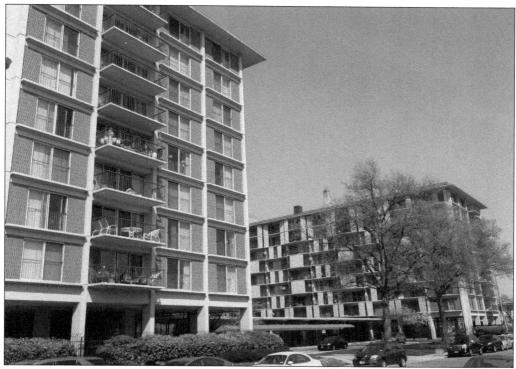

The Capitol Park complex extends to the 100 block of G Street SW, with the Twin Towers complex at 101 and 103 G Street. A passageway connects the two buildings, and the US Capitol can be seen in the background. (Both, authors' photographs.)

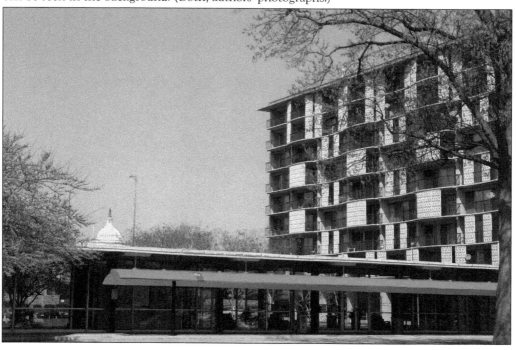

The developers and architects of the houses associated with the massive Capitol Park complex faced hurdles with myriad zoning ordinances that called for all houses built in the city to face the street on their own lots, issued nearly 90 years earlier to prevent the building of alley dwellings. Architect Chloethiel Woodard Smith convinced authorities that each cluster of houses was a building and thus was able to orient individual townhouses to their respective courtyards and parking lots. The setting was enhanced by collaboration with well-known landscape architect Daniel Urban Kiley. (Both, authors' photographs.)

Delays in the construction phase of the individual townhouses in the vast Capitol Park complex due to zoning ordinances and federal intervention led to today's unique design, as the developer and designer altered their plans to create a more urban and dense community. It was seen that good design was critical to the project's success, and thus each cluster of homes seems to have a distinctive and unique quality, even though many of the homes' layouts match each other. Passersby today would likely not be aware that the blocks of 380 townhouses were an integral aspect of the high-rises that frame the neighborhood. (Both, authors' photographs.)

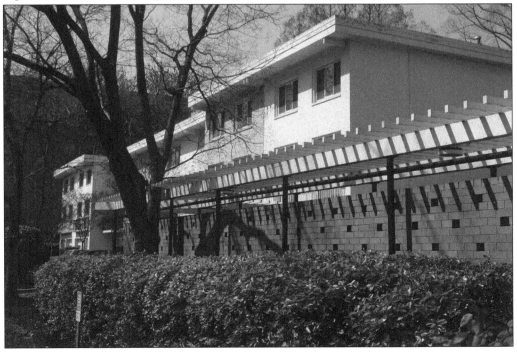

The Channel Square complex features a 203-unit high-rise and 75 garden apartments and townhouses. Designed by Harry Weese, noted for his Washington Metro system design, Channel Square is most distinguished by its unique semicircular arched openings on the brick townhouses. The development was one of the first moderate-income complexes in Washington. Channel Square continues to accommodate working-class families by offering one-, two-, three-, and four-bedroom units and a playground area. (Both, authors' photographs.)

Southwest is known for its diverse architecture and an array of options for housing, including these low-rise condominiums on Fourth Street. Here, residents can enjoy all the conveniences of urban living, with shops, restaurants, and public transit at their fingertips, yet also have the ability to tend to a small garden. (Both, authors' photographs.)

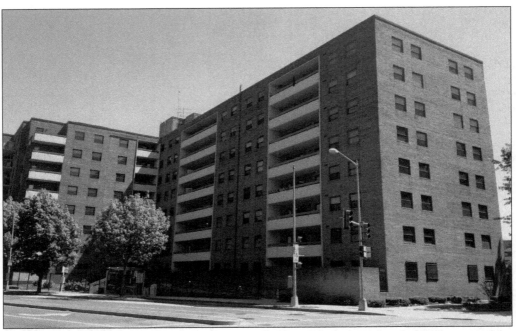

Greenleaf Gardens has long been the epicenter of a planned renovation and revitalization of the public housing units. The 15-acre public housing complex is slated to be redeveloped, with the almost 500 units undergoing renovation and the addition of over 1,000 new units. The complex was named after Massachusetts merchant James Greenleaf, who owned hundreds of lots in Southwest DC and whom Greenleaf Point is named after. (Both, authors' photographs.)

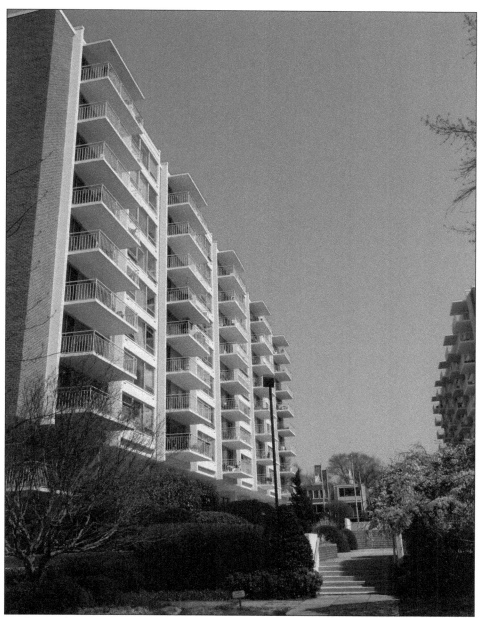

Riverside Condominiums is part of a development originally called Chalk House West and was designed by famed architect Morris Lapidus along with interior designers Haile and Liebman. Lapidus designed many of the glitzy hotels in Miami Beach, most famously the Fontainebleau. According to his obituary in the *New York Times*, "Lapidus's style was mockingly called Miami Beach French, and critics scorned the 'obscene panache' with which he created what they called his palaces of kitsch, many of which have been razed or remodeled. But as Miami Beach underwent a renaissance, becoming a trendy place for the jet set, the critical winds blew in his direction. After being shunned by architecture critics and architects for much of his long career, he and his work are now referred to with respect by a new generation of writers and postmodernist architects." (Authors' photograph.)

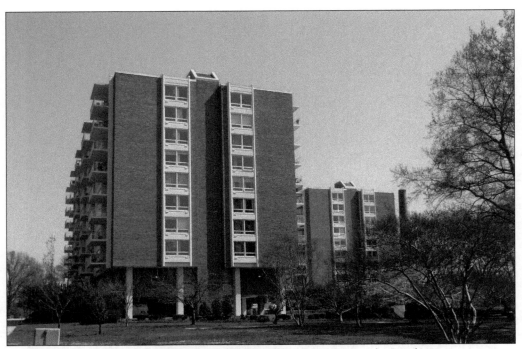

Riverside Condominiums was once a larger complex encompassing two high-rise buildings (still called Riverside), 32 garden apartments (now called Edgewater Condominium Apartments), and 12 townhouses. (Authors' photograph.)

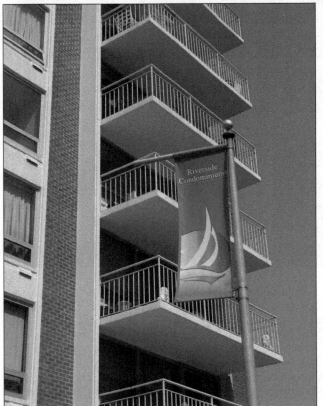

Riverside Condominiums takes advantage of its waterfront location in its marketing efforts and for good reason—the ability to live close to the water is an anomaly in Washington, DC. (Authors' photograph.)

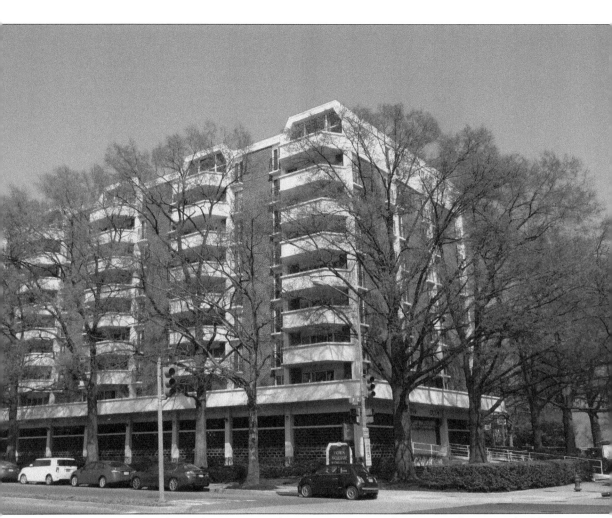

Town Square Towers, located at 700 Seventh Street SW, is an eight-story condominium building that extends for two blocks. It was designed by Cohen, Haft & Associates. The building features polygonal honeycomb balconies, a pattern that is transformed into arches on the roofline, creating cathedral ceilings in the penthouse units. The 285-unit, tree-lined building features an outdoor pool and pavilion, manicured grounds, and off-street indoor parking. (Authors' photograph.)

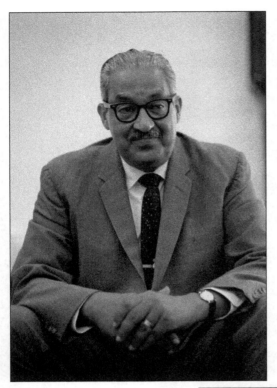

Due to its proximity to federal government buildings, Southwest DC has seen its fair share of famous residents, including Justice Thurgood Marshall, who lived at 64A G Street in a Capitol Park townhouse with his wife, Cissy, an active member at St. Augustine's Episcopal Church. Thurgood Marshall's long and successful career as a trial attorney culminated with the 1954 Supreme Court decision *Brown v. Board of Education*. In 1967, Pres. Lyndon B. Johnson nominated him to be the first African American on the Supreme Court. (LOC.)

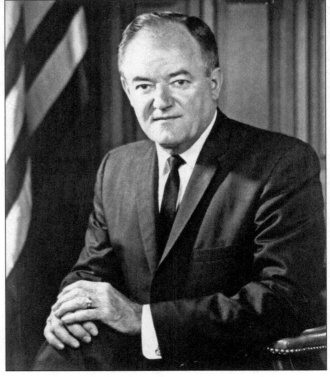

In October 1966, Vice Pres. Hubert H. Humphrey and his wife, Muriel, moved into a two-bedroom plus den co-op in Harbour Square overlooking the Potomac River, with a number of balconies that offer views in three different directions. Humphrey served as vice president under Lyndon Johnson and was a two-term US senator from Minnesota. He was the Democratic nominee in the 1968 presidential race but lost to Richard Nixon. (LOC.)

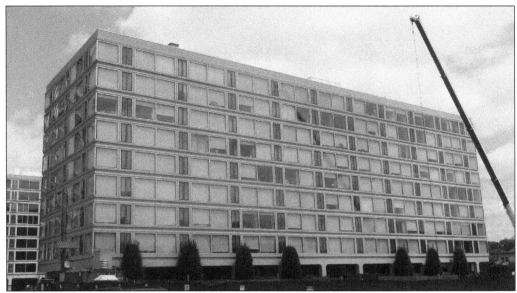

Originally part of the Town Center Plaza complex, Waterfront Tower (above) was designed in 1962 during the period of Southwest urban renewal. The property is an early work of the legendary architect I.M. Pei, who also designed the glass pyramid at the Louvre Museum in Paris and the East Wing of the National Gallery of Art, and is a prime example of mid-century modern architecture stressing International Style principles of light, air, and space. Located at 1101 Third Street SW (the companion building is seen below at 1100 Sixth Street, which is called the View at Waterfront), it was renovated beginning in 2009 by the Bernstein Companies. The View at Waterfront (below) has also been renovated, and both buildings offer convenient access to the Metro, Safeway, and area restaurants. (Both, authors' photographs.)

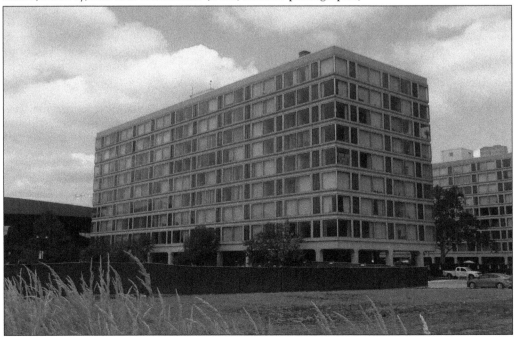

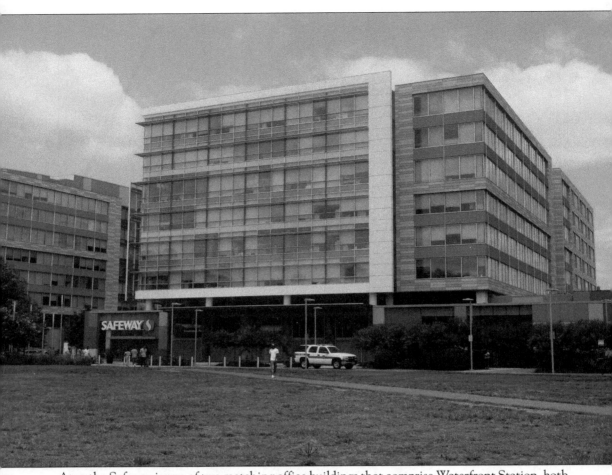

Atop the Safeway is one of two matching office buildings that comprise Waterfront Station, both of which are leased primarily to various DC government agencies—including the Department of Consumer and Regulatory Affairs, DC Office of Planning, and Tax and Revenue—and also house the offices of two local SW community organizations, the Southwest Neighborhood Assembly and the Advisory Neighborhood Commission. On the ground level are a few local restaurants. The project is slated to comprise seven new buildings totaling over two million square feet, including Class-A office space, new residential units, and neighborhood-oriented retail in the heart of Southwest. (Authors' photograph.)

The new developments close to the Waterfront Metro, including Waterfront Station, have included many public spaces to help create a livelier neighborhood. Here, children and adults alike enjoy the water sprays and benches in a parklike setting. (Authors' photograph.)

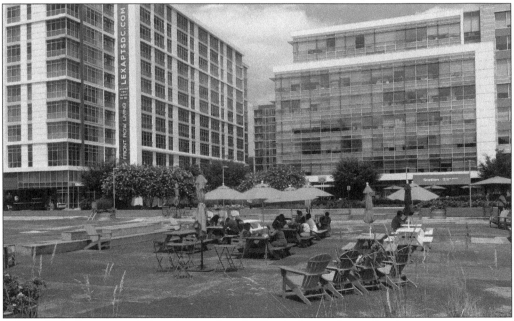

Adirondack chairs, picnic benches, and umbrellas in front of new developments present the perfect place for eating lunch outdoors for residents as well as those who work in the government offices at Waterfront Station. The site is also utilized for the Southwest Farmers Market, held on Saturdays. (Authors' photograph.)

Edgewater Condominium Apartments and its sister building, Riverside, are part of a development originally known as Chalk House West. The Edgewater portion contains 32 garden apartments with large balconies on a quiet cul-de-sac at 400 O Street SW. (Authors' photograph.)

The Capitol Square complex at Seventh and G Streets SW was built around 2000 by EYA, a local developer. The 93 modern townhomes have multiple courtyard areas, giving residents ample green spaces in proximity to federal office buildings, such as the Robert C. Weaver Federal Building, headquarters of the US Department of Housing and Urban Development, seen here. (Authors' photograph.)

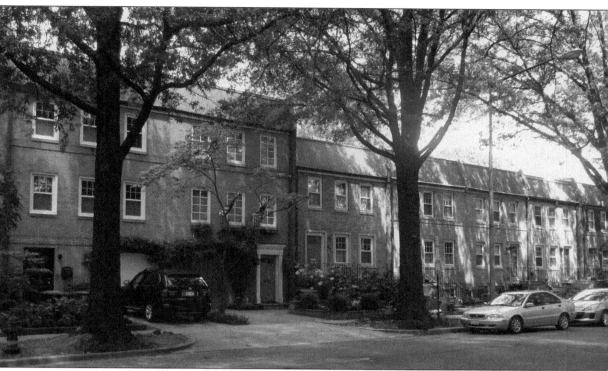

Constructed in the late 1960s as an entire square of townhouses, the dwellings on the north side of the 600 block of G Street adjacent to Town Square now enjoy the benefit of mature plantings that provide a modern-day translation of the traditional tree canopy Washington, DC, was so well known for at the beginning of the 20th century. (Authors' photograph.)

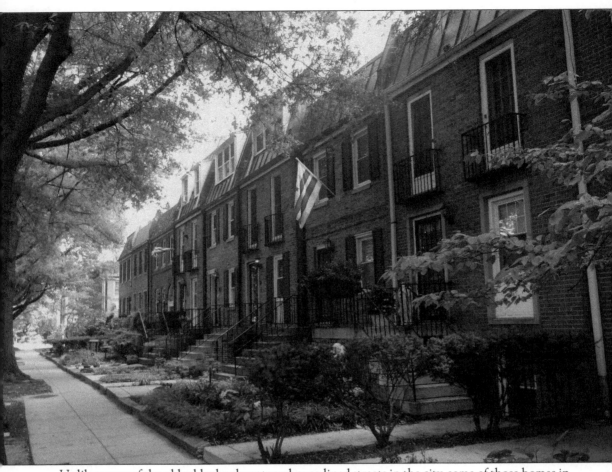

Unlike many of the older blocks along townhouse-lined streets in the city, some of those homes in the 600 block of G Street built in the 1960s adjacent to the Town Square complex were constructed with coveted urban garage parking. The diversity of housing types and sizes has allowed myriad social and economic populations to comingle in the neighborhood, which is very proud of its community. (Authors' photograph.)

Three

WATERFRONT LIVING

When people think of Washington, DC, most immediately picture the famous monuments to Lincoln, Washington, Jefferson, Roosevelt, and other famous Americans. Or they recall fondly hours spent walking around the various museums and art galleries. For most Americans, thinking of DC will not conjure up images of waterfront vistas, but for those fortunate enough to call Southwest DC home, waterfront living is a reality.

Boasting the East Coast's largest live-aboard boating community, Southwest DC offers waterfront living at its finest as residents climb aboard sailboats, trawlers, barge-style boats, and yachts to make their homes on the water. Not only do live-aboards enjoy picturesque sunsets on the water, but they are also minutes away from the National Mall and federal office buildings for an easy work commute. Weekly happy hours, holiday parties, and other social gatherings have created a tight-knit community not always seen in a large metropolitan area like Washington, DC.

Even for those who do not own a boat, many of the high-rise apartment, co-op, and condominium buildings in Southwest offer spectacular water views, while all residents have easy access to the Anacostia Riverwalk Trail to enjoy walking, biking, and in-line skating while taking in water views.

The Southwest Waterfront is also well known for the Municipal Fish Market, the oldest operating open-air fish market in the United States. Locals and visitors alike can enjoy the freshest seafood around by buying directly from the fishermen and their fleets.

The waterfront area is also undergoing a massive change in its landscape with the construction of the Wharf, a mixed-use project spanning the majority of the Southwest Waterfront, bringing a combination of new residential, office, dining, accommodation, and nightlife options to the area. The developers hope that this new project will expose even more locals and visitors to Southwest and the enjoyable waterfront experience.

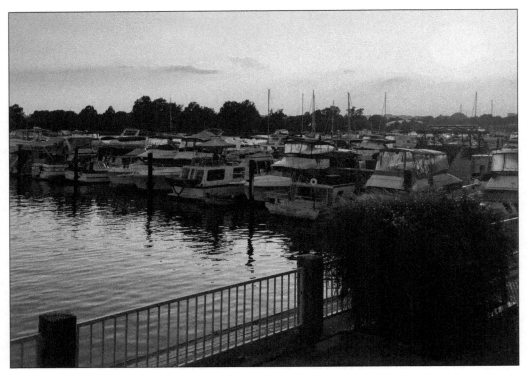

Southwest boasts Washington, DC's only live-aboard boating community and reportedly the largest such community on the East Coast. From sailboats to trawlers and houseboats to barges, a robust boating community thrives along the Southwest Waterfront in the Washington Channel. While historically the Washington Channel was a busy center for maritime trade and fishing, as well as an entry point for visitors to the nation's capital, the primary boating traffic today is more focused on recreation and sightseeing. (Both, Gangplank Marina Slipholders Association.)

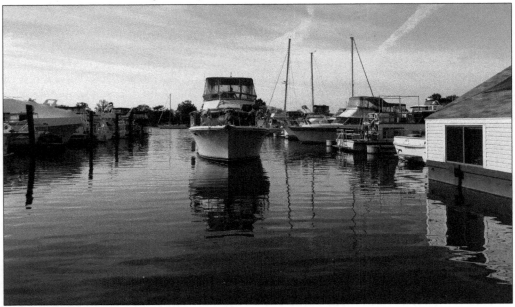

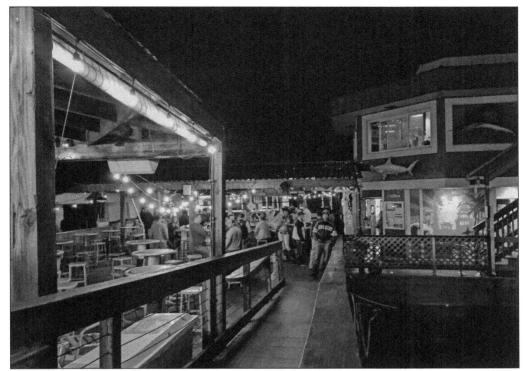

The Cantina Marina has been a popular restaurant and bar along the waterfront since its opening. At DC's only dock bar and restaurant, the vistas are unique, and boaters like the easy access for carryout food as well. Located at 600 Water Street, the Cantina Marina is a seasonal operation. (Gangplank Marina Slipholders Association.)

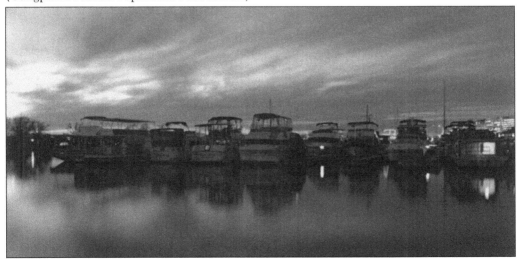

The Gangplank Marina is located within easy walking distance of the National Mall, with the museums of the Smithsonian and the National Gallery of Art, making it appealing to live-aboards and transient slip holders alike. The Gangplank Marina docks can accommodate vessels up to 125 feet in length with a beam of 32 feet, with several amenities, including showers, laundry facilities, cable television, and 24-hour security. (Gangplank Marina Slipholders Association.)

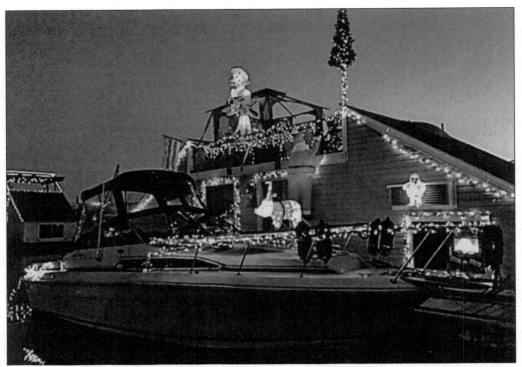

Live-aboards adorn their houseboats with decorations, making it clear that the holidays are not only for those in condos, townhomes, and single-family homes. Boaters also take advantage of kayaks, stand-up paddleboards, and dinghies to move about the marina during warmer months, and slip holders have events such as weekly happy hours and Captains' Coffee get-togethers to stay engaged. (Gangplank Marina Slipholders Association.)

The views cannot be beat when living aboard in Southwest DC, with the Jefferson Memorial and Washington Monument at one's doorstep. On any given evening, boaters can be seen relaxing on their boat after work, taking in Washington's beautiful sunsets and enjoying the serene, quiet atmosphere. (Gangplank Marina Slipholders Association.)

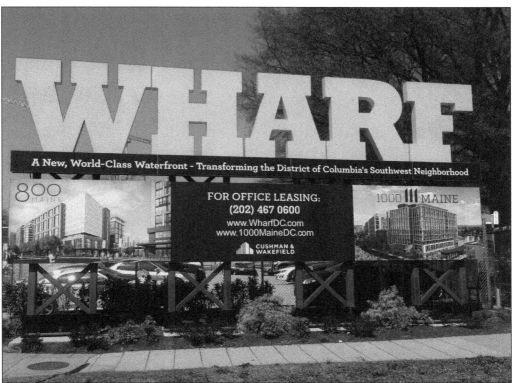

Southwest's waterfront will be forever changed with the completion of the Wharf, Hoffman-Madison Waterfront's revitalization effort for the Southwest Waterfront. The project will stretch across 24 acres of land and more than 50 acres of water from the Municipal Fish Market to Fort McNair. (Authors' photograph.)

The Anacostia Riverwalk Trail runs through Southwest, bringing locals from other areas of the city to the waterfront. Once complete, the trail will provide seamless, scenic travel for pedestrians and bicyclists along the river to the fish market, Nationals Park, Historic Anacostia, RFK Stadium, the National Arboretum, and 16 communities between the National Mall at the Tidal Basin and Bladensburg Marina Park in Maryland. (Authors' photograph.)

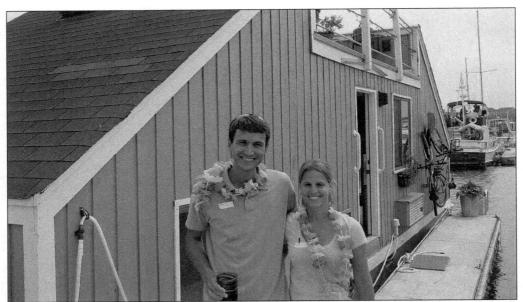

The Gangplank Marina Slipholders Association and the Port of Washington Yacht Club (located at Gangplank Marina) have sponsored "Boat-Home Tours" to welcome curious visitors interested in taking a look inside one of DC's most unique communities. Guests are invited aboard a variety of boat types, from sailboats to houseboats and 1970s-era boats to modern yachts. Seen here are boaters Snapper Poche and Janel Hoppes aboard *Serendipity 2* and Laneyse Hooks aboard her house barge *Our Island*, which has a rooftop garden where she grows corn and other vegetables. (Both, Perry Klein/the *Southwester.*)

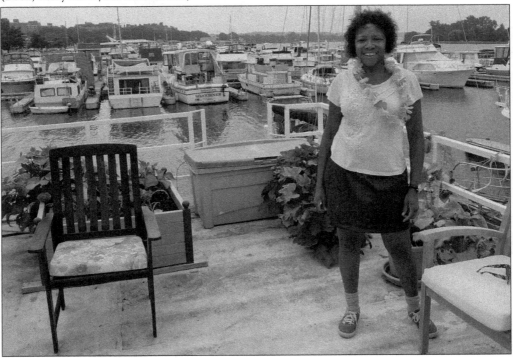

The incoming Wharf project threatened the future of the live-aboard community in Southwest, but the Gangplank Marina Slipholders Association worked with local officials, the Southwest community, and the developers to ensure that the unique community would remain. There is still uneasiness about how the new marina will affect the cost to live aboard and if it will offer a different lifestyle that may be in conflict with the traditional vibe and character of the waterfront community. Still, the location and proximity to fireworks shows make living on the water an attractive option for many Washingtonians. (Both, Gangplank Marina Slipholders Association.)

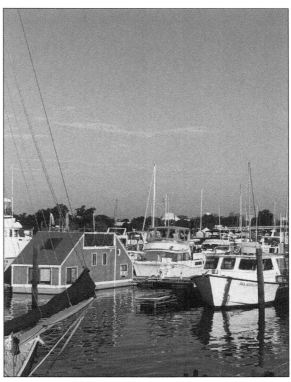

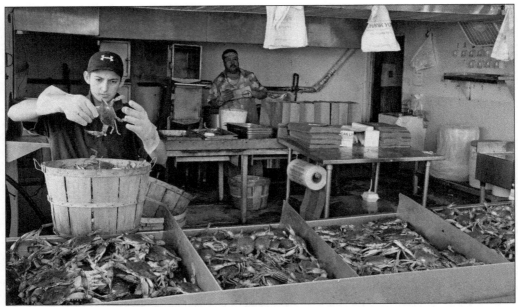

The Municipal Fish Wharf in Washington, DC, is one of the oldest and busiest food markets in America. The Maine Avenue SW location dates back to 1805 (it was relocated in the 1960s a short distance from its original location), when most of the fish and seafood sold there came from the Potomac River and its tributaries, and oysters, clams, crabs, and fish came from the Chesapeake Bay. (LOC.)

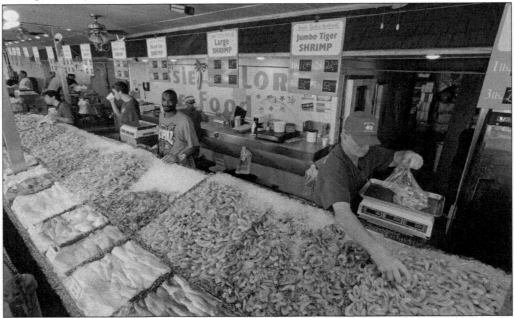

The Municipal Fish Market is the oldest operating open-air fish market in the United States, predating New York City's Fulton Fish Market by 17 years. In 1913, the US Congress formally declared the Municipal Fish Wharf to be "the sole wharf for landing of fish and oysters for the sale in the District of Columbia." (LOC.)

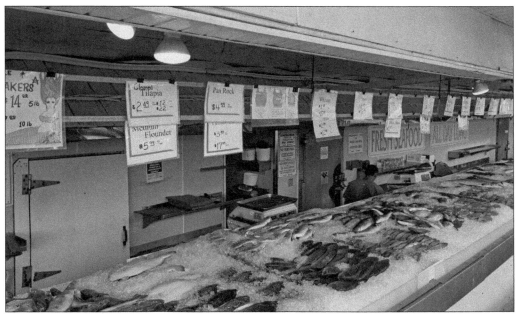

Due to its location under Interstate 395 and away from the popular monuments, the Fish Market is more of a draw for locals than tourists. Vendors are open seven days a week, but the majority of the traffic is seen on weekends, when most vendors increase their offerings. (LOC.)

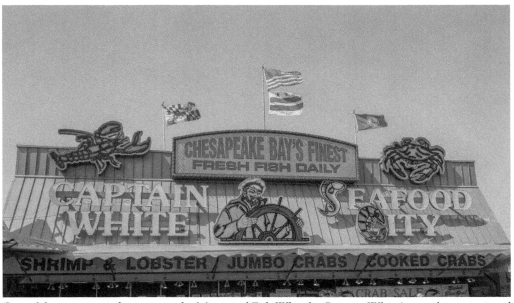

One of the most storied tenants at the Municipal Fish Wharf is Captain White's, a multigenerational business that is still family-owned. Locals head to Captain White's for Dungeness crab, oysters, clams, salmon, shrimp, fish, lobster, crawfish, and more. (Authors' photograph.)

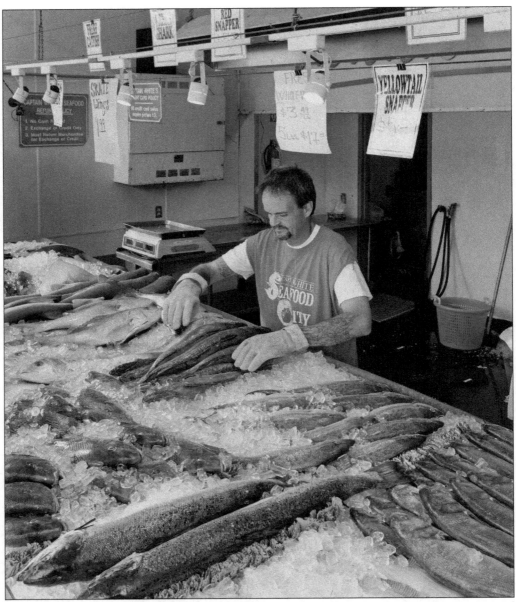

Locals head to the seafood market for fresh fish to cook at home, and some opt to have it prepared by the vendors. It is also a popular spot to grab lunch for those who live or work in Southwest DC. According to the developers, as part of the redevelopment of the Southwest Waterfront, the existing fish market will be retained. Plans include the restoration of the historic oyster shed; a new operations building; a new fish-cleaning building; the addition of a new distillery; a new market hall; and retail additions that include a market shed and two small market pavilions. To reduce congestion, new below-grade parking will be added, and a nearby signaled intersection on Maine Avenue will improve vehicular access into the site. Finally, a new Market Plaza, Market Pier, and Market Square will be added that will augment the public enjoyment of this one-of-a-kind experience on the waterfront. (LOC.)

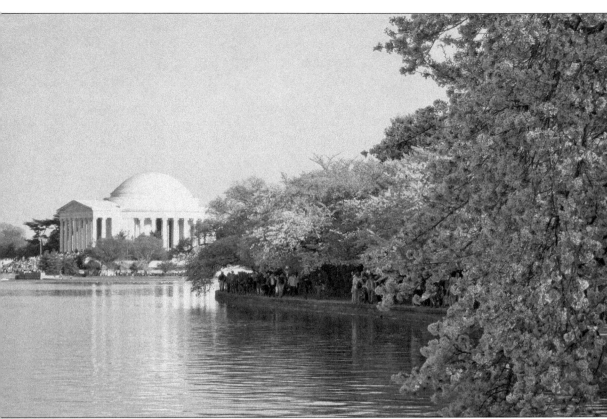

Each year, the National Cherry Blossom Festival commemorates the 1912 gift of 3,000 cherry trees from Mayor Yukio Ozaki of Tokyo to the City of Washington, DC. The gift and annual celebration honor the lasting friendship between the United States and Japan and the continued close relationship between the two countries. In a simple ceremony on March 27, 1912, First Lady Helen Herron Taft and Viscountess Chinda, wife of the Japanese ambassador, planted the first two trees from Japan on the north bank of the Tidal Basin in West Potomac Park. Thousands of visitors from around the world descend each year on Southwest to view the trees. Today, the festival spans four weekends and welcomes more than 1.5 million people a year to enjoy diverse programming and the trees. Over the years, millions have participated in the annual event that heralds spring in the nation's capital. (National Cherry Blossom Festival.)

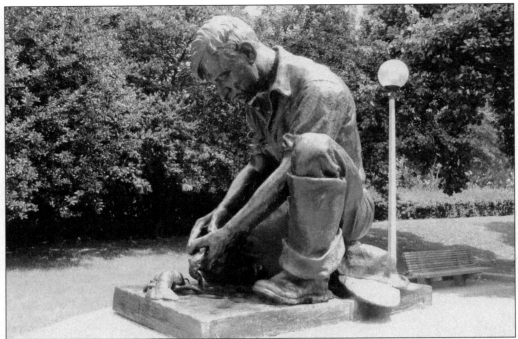

The *Maine Lobsterman* statue on the Southwest Waterfront is a replica of a sculpture created for the 1939 World's Fair in New York to showcase Maine's economic contribution to the United States. With the area under redevelopment, it has temporarily been put in storage until it can be reinstalled. Sen. Susan Collins of Maine and Rep. Eleanor Holmes Norton of Washington, DC, fought to ensure that it will remain on the waterfront. (mapio.net.)

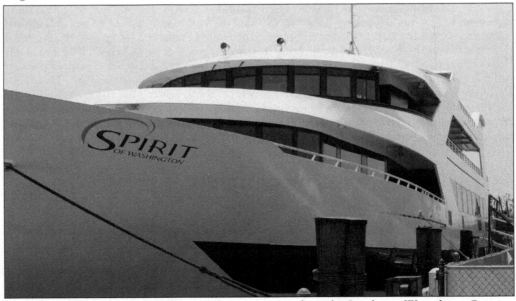

Spirit Cruises is one of many sightseeing boat operators along the Southwest Waterfront. Cruising the Potomac River, Spirit offers lunch, dinner, and holiday cruises, plus a variety of themed cruises, as well as corporate events, birthdays, and weddings. (Authors' photograph.)

The juxtaposition of tall high-rise condominium and co-op buildings next to two-story townhomes is jarring at times along the Southwest Waterfront. Both housing options offer unobstructed views of the Washington Channel and easy access to the Anacostia Riverwalk Trail. (Authors' photograph.)

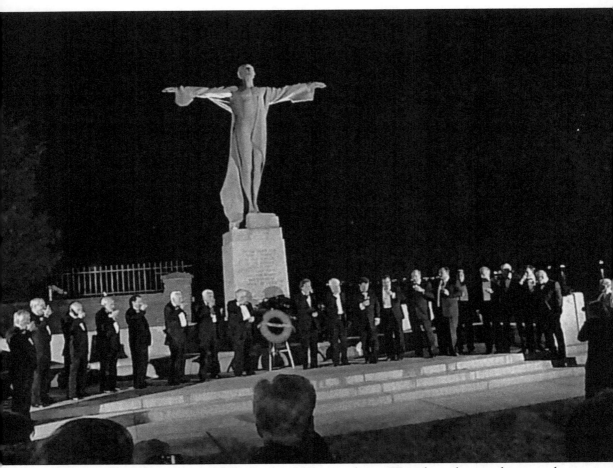

The Titanic Memorial, a granite statue along the Southwest Waterfront, honors the men who lost their lives when the *Titanic* sank. It was originally located on the Potomac River along New Hampshire Avenue but was relocated to make way for the John F. Kennedy Center for the Performing Arts. The memorial is 13 feet tall and was designed by Gertrude Vanderbilt Whitney. Each year after midnight on April 15, the Men's Titanic Society, in formal attire, meets at the Titanic Memorial to toast "the brave men who gave their lives that women and children might be saved." Earlier in the evening, the society has a formal dinner, with one empty seat in memory of the fallen. Seen here is a photograph from 2012, the centennial commemoration of the sinking of the *Titanic*. The wreath is left at the statue after the ceremony each year. (*Southwester.*)

Four

THE SOUTHWEST LIFESTYLE

Like all Washingtonians, residents of Southwest have more to their lives than working (thankfully). And as the "live, work, play" movement gains steam, residents desire easy access to their work from their homes, as well as having restaurants, shops, everyday conveniences, and more close to home. The expansion of the DC Metro to include the Southwest Waterfront station improved daily lives for Southwest residents, and the influx of federal buildings to the neighborhoods since the 1960s redevelopment plan has allowed for many residents to walk to work or jump on the Metro for an easier commute. Zipcar and Capital Bike-Share stations are located throughout the neighborhood and have become very popular options for transportation, replacing the need for car ownership for many residents.

Places to dine out, grocery stores to grab food necessities, and other everyday conveniences such as a local drugstore have increased as well, providing Southwest residents a better quality of life and a tighter-knit community.

Enhancing this feeling of a close-knit community, Southwest residents also have the advantage of having schools, churches, and a public library right in their neighborhood.

Locals and visitors alike are drawn to Southwest for its cultural attractions, too. Arena Stage is seen as a pioneer in the regional theater movement and is world-renowned for its productions with a focus on American theater. Hundreds of thousands of theater patrons head to the newly renovated Arena Stage at the Mead Center for American Theater in Southwest each year. Even more come to Southwest DC each year to visit the US Holocaust Memorial Museum and many Smithsonian museums that call Southwest home—from the National Air and Space Museum to the National Museum of the American Indian, National Museum of African Art, and the Hirshhorn Museum and Sculpture Garden.

Living in an urban environment has its advantages, with cultural and commercial institutions close to home, but residents sometimes need to reconnect with nature, and the neighborhood's parks and walking trails provide a retreat from city life.

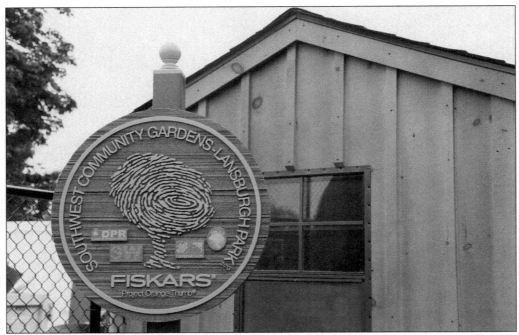

Originally constructed in 1964 as part of urban renewal and named for Mark Lansburgh, director of the city's Redevelopment Land Agency, Lansburgh Park on Delaware Avenue was enhanced in 2013 thanks to a grant valued at $50,000 awarded to the SW Community Gardens group through a nationwide competition—Project Orange Thumb Garden Makeover by Fiskars, with additional assistance by the Home Depot Foundation. The Lansburgh Park Community Garden is a place for meditative gardening and community programming for veterans, youth, students, and seniors. The 6,500-square-foot garden provides educational opportunities and gives community members a place to reap the rewards of growing their own fresh food. Another organization, PAWS of Southwest, helped open a dog park in 2014, making Lansburgh Park even more attractive to residents. (Both photographs by Moody Graham.)

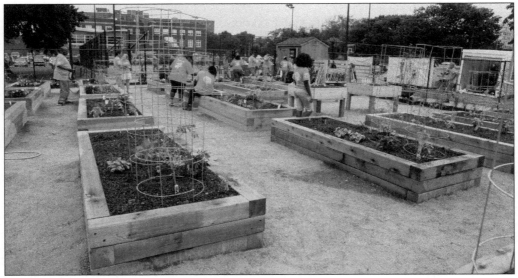

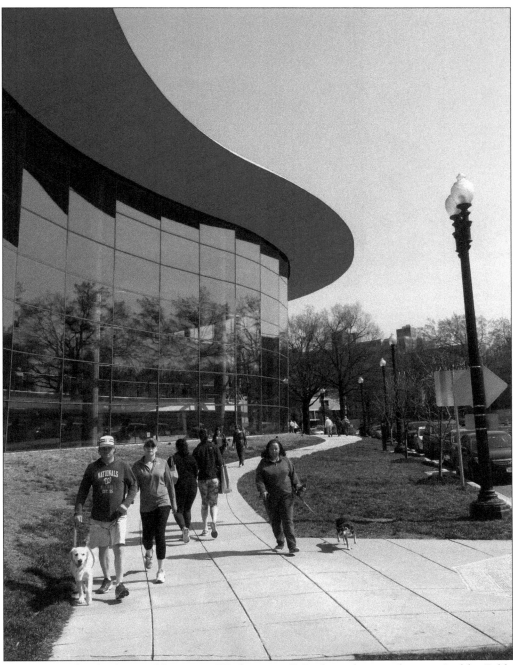

Arena Stage has had several homes in Washington, DC, throughout its history. Led by Zelda Fichandler, Tom Fichandler, and Edward Mangum, the theater group converted the Hippodrome, a former burlesque and movie house at Ninth Street and New York Avenue NW, into a 247-seat theater-in-the-round. Five years later, the group moved to the "Old Vat" before building its current location in 1961 at 1101 Sixth Street SW. (Authors' photograph.)

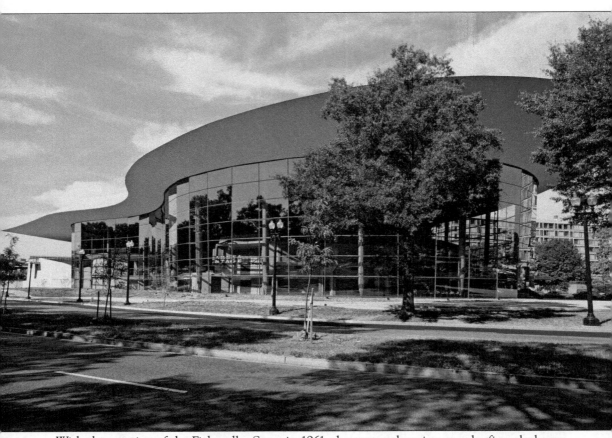

With the opening of the Fichandler Stage in 1961, the current location was the first playhouse to be built in the nation's capital since 1895. In 1971, Arena Stage expanded with the opening of a second performance space, the Kreeger Theater. In 2008–2010, a massive renovation and expansion project was done; a third theater (the Kogod Cradle) and open common spaces were added, and a transparent exterior design is now a landmark. (LOC.)

Part of Cultural Tourism DC's Heritage Trails, the Southwest Heritage Trail, "River Farms to Urban Towers," aims to guide visitors through Southwest via 17 poster-sized illustrated signs that combine storytelling with historic images. The first sign is located at the Waterfront Metro station plaza, and the self-guided tour takes visitors down Fourth Street and then along the waterfront toward Fort McNair. (Authors' photograph.)

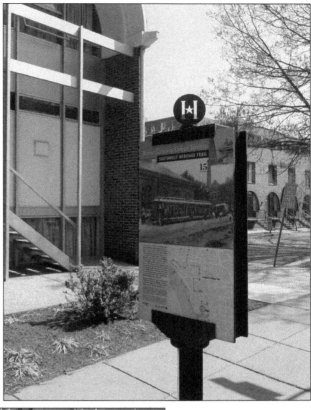

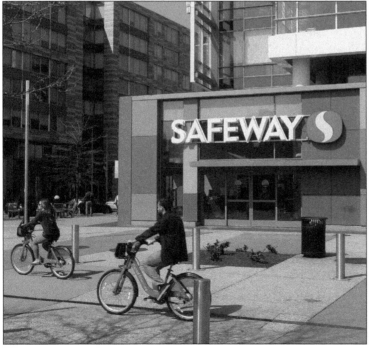

Seeing a need for a modern grocery store geared toward today's lifestyles and food tastes, a new, state-of-the-art Safeway opened at 1100 Fourth Street SW in 2010. At over 50,000 square feet, the new Safeway was a definite upgrade to the former store, and the adjacent Metro station and Capital Bikeshare station make it convenient for residents. (Authors' photograph.)

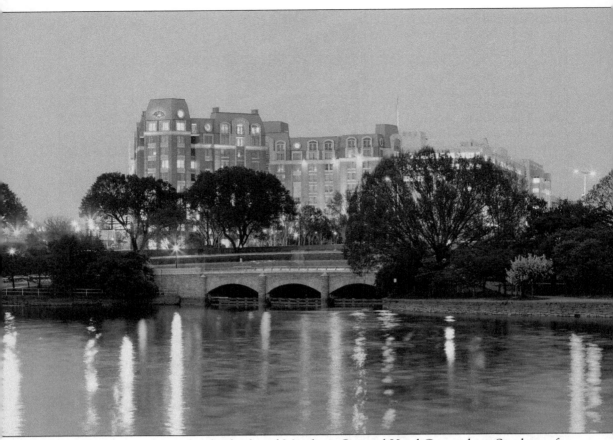

To the surprise of some locals, the famed Mandarin Oriental Hotel Group chose Southwest for its foray into the DC market in 2004. Capitalizing on the waterfront location and views of both the Jefferson Memorial and Washington Monument, the hotel, at 1330 Maryland Avenue SW, is nine stories tall and features neoclassical architecture and ornate columns with a feng shui interior design. (Mandarin Oriental Hotel Group.)

The opening of the Waterfront Metro and the welcoming plazas off Fourth Street present great opportunities for restaurants to move in and offer dining al fresco. Here, Station 4 American Bistro takes advantage of pleasant spring weather to feature outdoor tables for diners. (Authors' photograph.)

Flowerboxes outside the new Safeway help give a softer touch to an otherwise concrete urban environment. The grocery store's convenient location allows longtime residents the opportunity to walk home with groceries, and the Starbucks on-site draws locals to the outdoor tables. (Authors' photograph.)

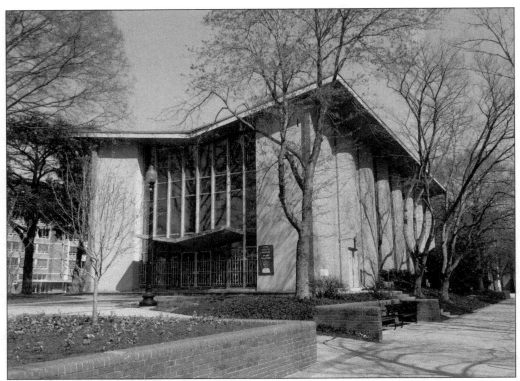

Christ United Methodist Church, at 900 Fourth Street SW, was formed in 1961 with the merger of Gorsuch Methodist Church and Louis Memorial Congregation. After acquiring the site at Fourth and I Streets, the cornerstone of the church was laid on October 21, 1962, the first ground-breaking of a church in the newly developed Southwest quadrant. The first service was held on April 7, 1963. (Authors' photograph.)

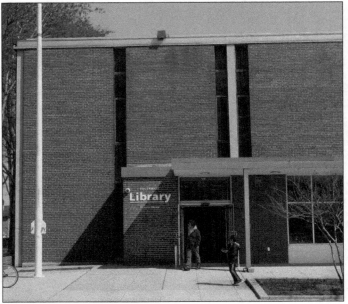

The Southwest Neighborhood Library, which originally was located in a wing of Thomas Jefferson Memorial Junior High School, moved to its own freestanding, two-story, redbrick building at 900 Wesley Place SW in 1965. The building was designed by the architectural firm Clas & Riggs, and Congress appropriated construction funds approximating $635,000. In 1976, the Friends of the Southwest Neighborhood Library was formed to provide volunteer and financial support to the branch. (Authors' photograph.)

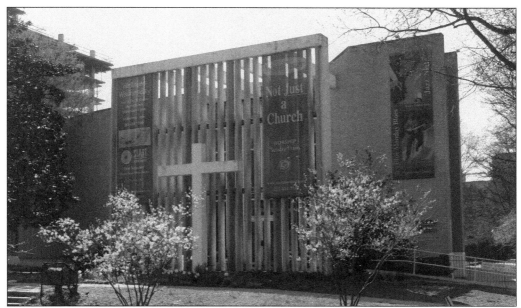

Originally founded in 1853, Westminster Presbyterian Church, at 400 I Street SW, is known for its motto—"Not Just a Church." Its social outreach programs have included housing poor homeless families and ministering to people with HIV/AIDS in the early days of the epidemic. It also hosts the very popular Jazz Night in Southwest on Fridays and Blue Monday Blues on Mondays, both of which feature local jazz musicians. (Authors' photograph.)

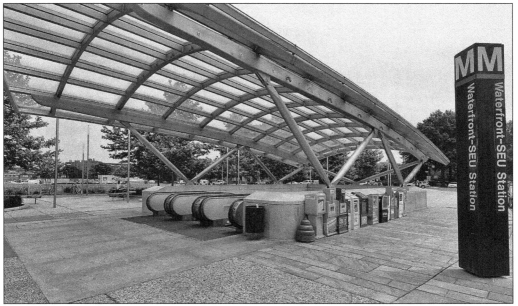

Creating increased transit options for residents and bringing tourists to Southwest, the Metro station at Fourth and M Streets SW opened in 1991. Originally slated to open in 1983, it was delayed for several years due to litigation surrounding where the Green Line would end in Maryland. It was originally named the Waterfront station; however, SEU was added to the name to recognize nearby Southeastern University, which subsequently closed. (Authors' photograph.)

Amidon-Bowen Elementary School, at 401 I Street SW, is a public DC elementary school serving pre-kindergarten (age 3) through fifth grade. As an early action prekindergarten school, it guarantees students who live in-boundary a seat in three- and four-year-old pre-k as long as the family submits an application through the My School DC lottery by the deadline, lists Amidon-Bowen as one of its 12 school choices, and is not matched with a school it ranked higher. The school is constantly enhancing its curriculum, and in the 2016–2017 academic year, it added a new STEM focus for elementary school students and a full-time Spanish teacher. (Both, authors' photographs.)

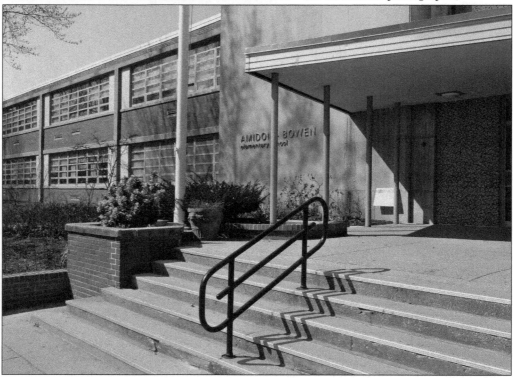

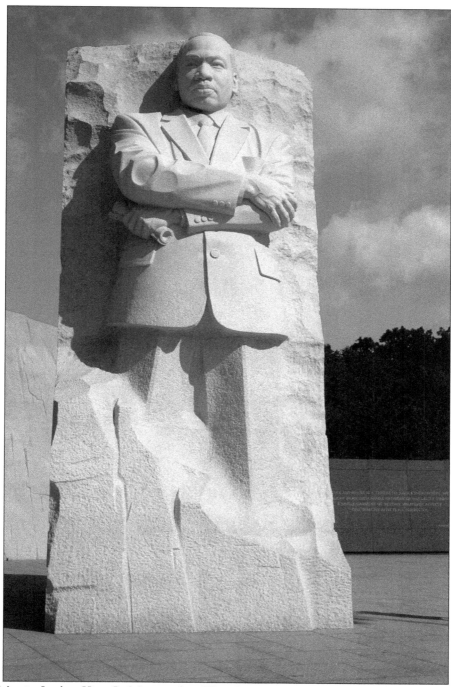

The Martin Luther King Jr. Memorial in West Potomac Park draws thousands of visitors to Southwest each year. The memorial, located at 900 Ohio Drive SW, was dedicated in 2011 and is the first memorial to an African American on or near the National Mall. King is the fourth non-president to be remembered in such a way, according to the National Park Service. (Authors' photograph.)

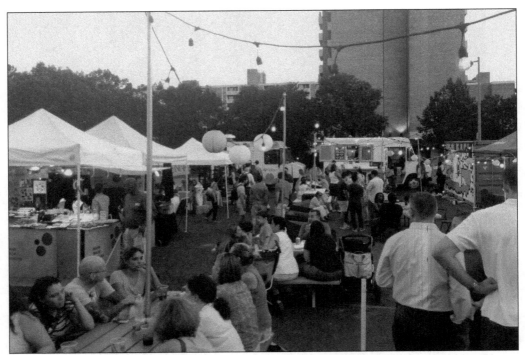

MarketSW, a monthly arts market at Waterfront Station that began in 2015, is unique in that it is a night market and features a diverse mix of art, crafts, handmade jewelry, accessories, vintage and antique furniture, furnishings, and collectibles. The market also draws visitors to the area to enjoy the live music, food trucks, and beer garden. (Diverse Markets Management.)

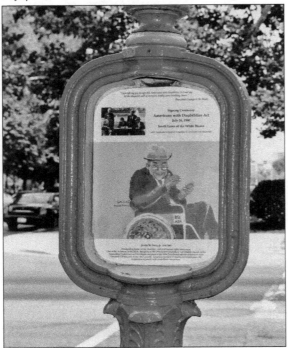

A callbox on Sixth Street SW honors Justin Dart Jr., who moved to Southwest to work for the passage of the Americans with Disabilities Act (ADA). His tireless advocacy for the passage of ADA was his lifelong work. He and his wife, Yoshiko, lived for several years in Waterside Towers at 907 Sixth Street, and he was known for his signature cowboy hat and boots. The artwork was commissioned by the Southwest Neighborhood Assembly to Richard Treanor, a Southwest artist who lived a block away. (Perry Klein/the *Southwester*.)

Longtime Southwest residents Drs. Susan and Perry Klein stand by the first of two adjacent callboxes they had decorated at 700 Seventh Street SW, this one honoring civil rights leader Dr. Dorothy Height, who lived in the Town Square Towers Condominium building for decades. In her paid and volunteer activities at the YWCA of USA, the National Council of Negro Women, and other organizations, Dr. Height (seen below before the completion of the callbox and who died in 2010 at the age of 98, a year before its unveiling) worked with many nationally known civil rights leaders. She won many awards, including the Congressional Gold Medal, which was presented to her in 2004 by Pres. George W. Bush. (Both, *Southwester.*)

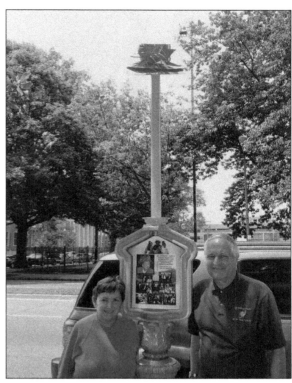

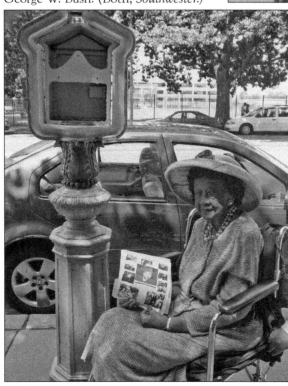

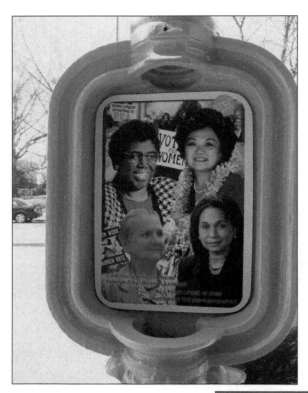

Adjacent to Dr. Dorothy Height's callbox is a second one dedicated to four prominent women civil rights leaders who lived within two blocks—(clockwise from upper left) Barbara Jordan, Patsy Mink, Alexis Herman, and Molly Yard. Jordan was a congresswoman from Texas and the first black woman elected to Congress from the South. Mink was a congresswoman from Hawaii and fought for the passage of Title IX to prohibit sex discrimination in education. Herman served in the US Department of Labor under two US presidents, as director of the Women's Bureau, and later as secretary of labor; and Yard was the president of the National Organization for Women. (Perry Klein/the *Southwester.*)

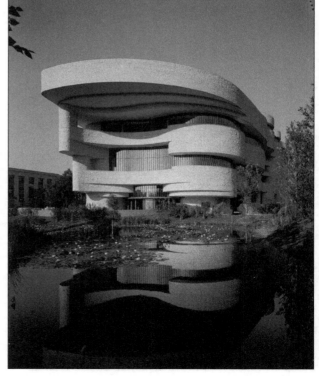

The east entrance of the Smithsonian's National Museum of the American Indian showcases a wetlands area and was built to represent the original Chesapeake Bay environment prior to European settlement. The design is meant to recognize the importance of indigenous peoples' connection to the land. The National Museum of the American Indian is home to more than 27,000 trees, shrubs, and herbaceous plants representing 145 species. (© 2004 Judy Davis/ Hoachlander Davis Photography for the Smithsonian.)

The curvilinear design of the National Museum of the American Indian represents a wind-sculpted rock formation. Other symbols representing the importance of the earth to Native Americas can be seen throughout the museum. The museum holds one of the world's largest collections of Native American artifacts and opened in 2004. (© 2004 Judy Davis/Hoachlander Davis Photography for the Smithsonian.)

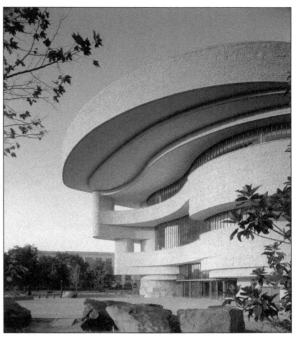

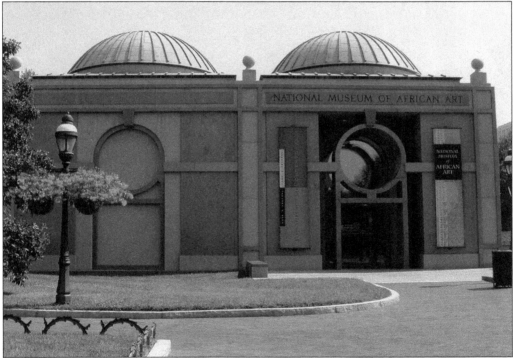

The Smithsonian's National Museum of African Art opened in 1987 on the National Mall, but its history dates back to 1964, when Warren M. Robbins, a former US State Department diplomat, founded the museum in the former Capitol Hill home of Frederick Douglass. Today, the museum has over 10,000 objects representing the diverse nature of Africa. (Smithsonian.)

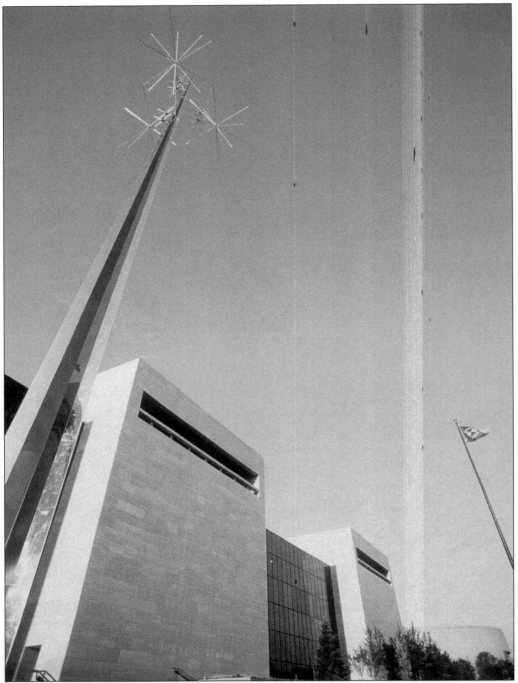

The National Air and Space Museum is one of the most popular Smithsonian museums in Washington, DC. The museum opened in 1976 and was an immediate hit. Within six months of opening, five million people had already visited the museum, and it remains one of the most visited museums in the world. (Smithsonian.)

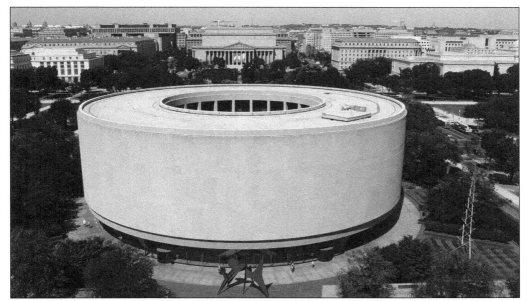

The Hirshhorn Museum and Sculpture Garden opened in 1974 and was a gift to the United States from financier and avid collector of modern art Joseph H. Hirshhorn, who began collecting art in 1917. The initial gift numbered more than 6,000 pieces of art, and Hirshhorn bequeathed the museum an additional 6,000 items and an endowment of $5 million at his death. The museum was the first truly modern building on the National Mall. (Smithsonian.)

DC public officials and local residents dedicate speed bumps at the side of the King-Greenleaf Recreation Center (seen behind them). The King-Greenleaf Recreation Center at 201 N Street SW serves as a gathering place for residents of all ages, from children to the group that calls itself the "Sassy Seniors." It is operated by the DC Department of Parks and Recreation and has been upgraded with new playground equipment and tennis courts. (Perry Klein/the *Southwester*.)

The Randall Recreation Center, located at South Capitol Street & I Street SW, is operated by the DC Department of Parks and Recreation and contains Southwest's only public swimming pool, which is quite popular. Randall also has a state-of-the-art baseball field named after Washington Nationals first baseman Ryan Zimmerman, who sponsored it with the Cal Ripken Foundation, as well as a community center that offers free programs for the community. The annual Doggie Day Swim, held at the end of the pool season, allows locals to let their dogs romp in the Randall pool. (Perry Klein/the *Southwester*.)

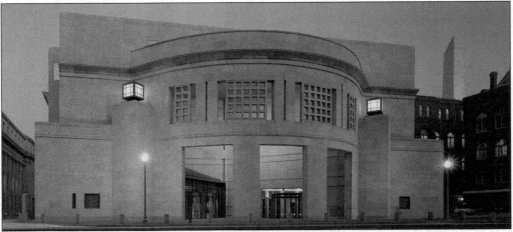

The US Holocaust Memorial Museum, located at 100 Raoul Wallenberg Place SW, opened in 1993. Since its opening, more than 40 million visitors have come to the museum, and approximately 90 percent of the visitors have been non-Jewish, illustrating its broad appeal. Almost 100 heads of state and more than 3,500 foreign officials from over 132 countries have also visited. Seen here is the Fourteenth Street entrance to the museum. (Timothy Hursley, US Holocaust Memorial Museum.)

Five

RECENT AND FUTURE DEVELOPMENT

In the 1960s and 1970s, Southwest DC saw a change in its landscape unlike any other. The dramatic change was unique in the history of the nation's capital, and few American metropolitan cities have seen a similar massive transformation. During this time, thousands of homes were demolished and large apartment and condominium buildings rose from the ashes. Urban planning took on a new level in Southwest, and its model has been studied for decades by urban planners, architects, and government officials.

To think that Southwest's transformation was complete at the close of the 1970s into the early 1980s would be incorrect. The neighborhood has seen subsequent development—additional high-rise residential buildings, single-family homes, commercial entities, and more have called Southwest home.

Over the past few years, there has been a heightened emphasis on the Southwest Waterfront. Most notable is one of the most ambitious projects Washington, DC, has seen in decades. The Wharf is a multiuse project spanning the majority of the waterfront, with residential units, ample office space, retail space, hundreds of hotel rooms, a concert hall, a marina, underground parking, and 10 acres of open space. The project is especially interesting with its emphasis on outdoor space—a series of mews encourages meandering, parks and green space abound, and a large pier will welcome festivals, concerts, and other events.

Not to be outdone, DC United, the city's major-league soccer team, will finally have a new home in Southwest near Buzzard Point—after years of residing in dilapidated RFK Stadium. The team's flashy new stadium near Nationals Park has been years in the making.

And the residential boom continues in Southwest with a host of new condo and apartment buildings. This chapter showcases a few—from 525 Water to VIO, the Lex, and the Leo.

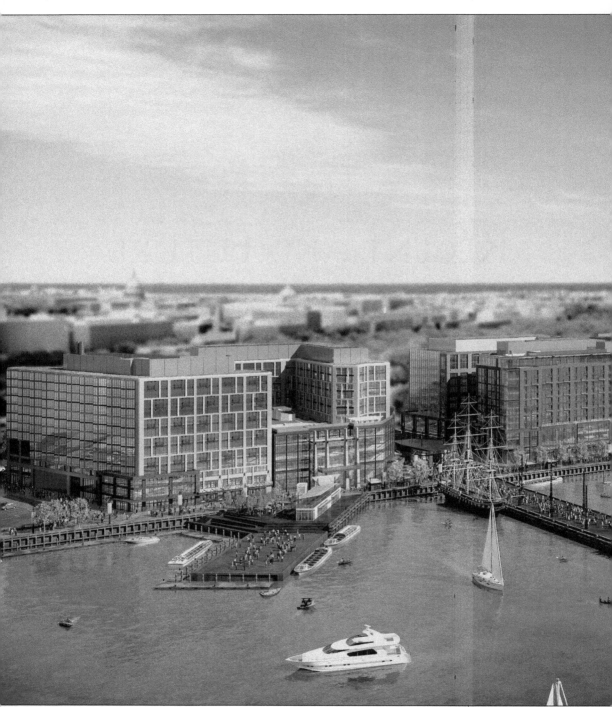

The most ambitious development that Southwest has witnessed in decades is the Wharf, a massive mixed-use project conceived by international architecture firm Perkins Eastman. The waterfront development aims to serve all variety of commercial and residential needs while also prioritizing public spaces. The Wharf project includes 1,300 residential units, 960,000 square feet

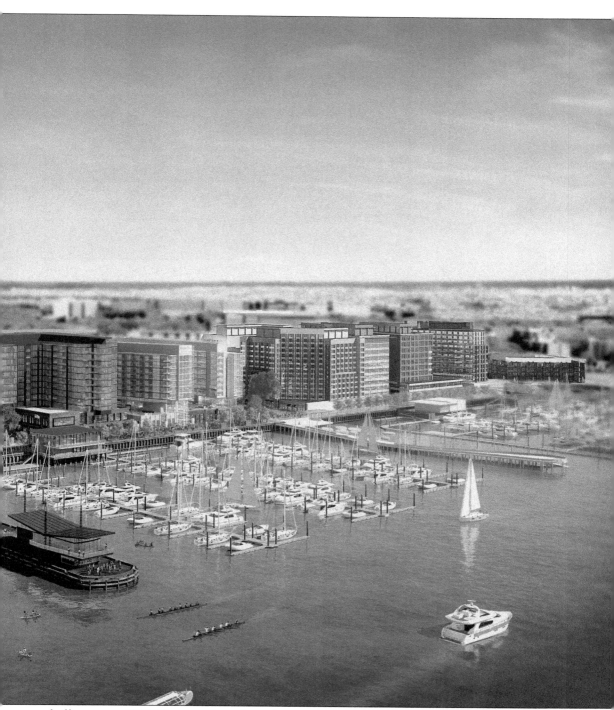

of office space, 358,000 square feet of retail space, over 600 hotel rooms, a 6,000-seat concert hall, a marina, underground parking, and 10 acres of open space. Capitalizing on the waterfront vistas, the Wharf will serve as an anchor for future developments and a destination for locals and tourists alike. (Perkins Eastman DC.)

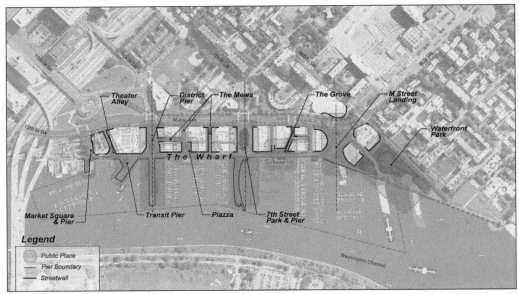

Open, public spaces are the heart of the master plan for the Wharf. While everything from hotels and restaurants to office buildings and private residences will contribute to the neighborhood's financial stability, public green space, mews, and piers are among the places that will make the Wharf the next great place not only for this quadrant of DC but also for the entire city. (Perkins Eastman DC.)

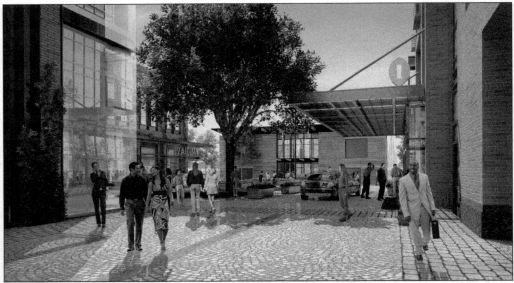

The Wharf's outdoor spaces are connected by a series of mews running between the waterside promenade and landside Maine Avenue. From nightlife and retail offerings to shaded seating areas, each of the mews possesses a unique character and is designed to safely accommodate both vehicular and pedestrian traffic. (Perkins Eastman DC.)

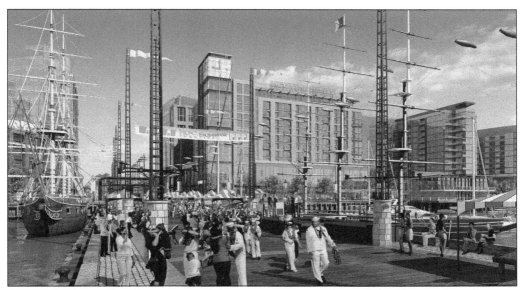

District Pier's grand and monumental form creates a central portal for all arrivals, welcoming visitors who are approaching from both land and water. From this unique vantage point, visitors will be afforded unparalleled views of the District of Columbia. (Perkins Eastman DC.)

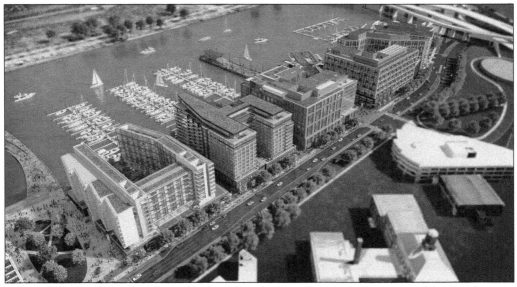

Inland from the Wharf is Maine Avenue, the corridor that connects the neighborhood's main business district. A series of new environmentally friendly buildings and open green spaces will line the avenue while providing varied gateways to the waterfront. (Perkins Eastman DC.)

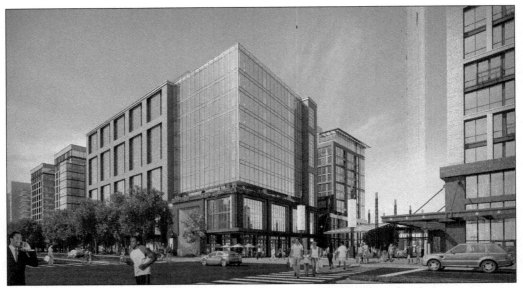

The jewel of Maine Avenue will be 800 Maine, an 11-story office building that features a stunning glass curtain wall, clearly marking the point of convergence where this growing business district meets the Wharf and leads onto District Pier. The building will feature efficient and flexible 21,000-square-foot floor plans with nine-foot finished ceilings, not to mention spectacular views of the US Capitol and Washington Channel. (Perkins Eastman DC.)

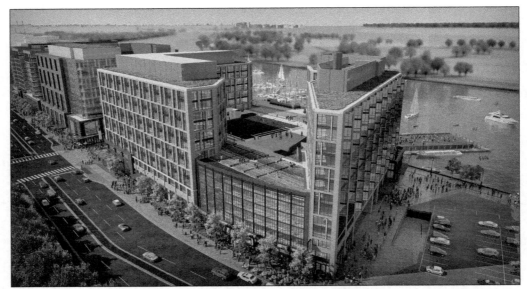

The energy and movement of Maine Avenue and District Pier interact with the building on opposite sides, creating a vibrant and sustainable urban work environment. Nearby will be the Wharf's District Pier, slated to be 55 feet wide and 450 feet long, which will serve as the port of call for tall and oversized ships arriving into the District. (Perkins Eastman DC.)

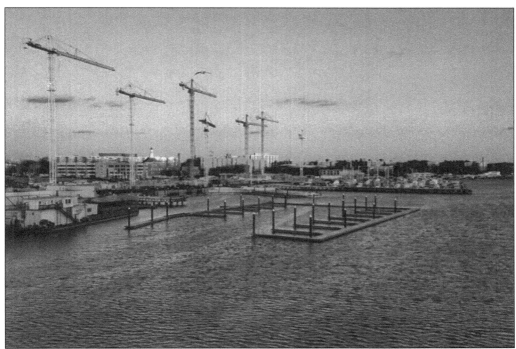

The ever-present construction cranes are a testament to the incredible number of new development projects in Southwest DC. As the neighborhood witnesses commercial and residential growth, boat owners are also eyeing Southwest as a prime location to call home. (Above, photograph by Jason Kopp, Gangplank Slipholders Association; right, photograph by the authors.)

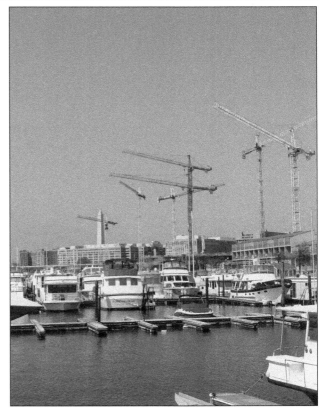

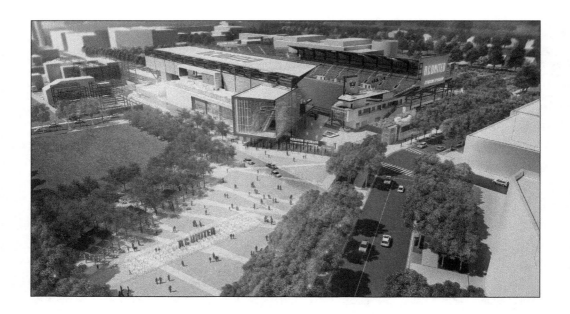

A new 20,000-seat soccer stadium is being built at Buzzard Point. The $300-million, state-of-the-art facility is a public-private partnership that will help revitalize a neighborhood on the banks of the Anacostia River and create nearly 900 job opportunities for District residents. The stadium is scheduled to open in the spring of 2018. (Both, Populous/DC United.)

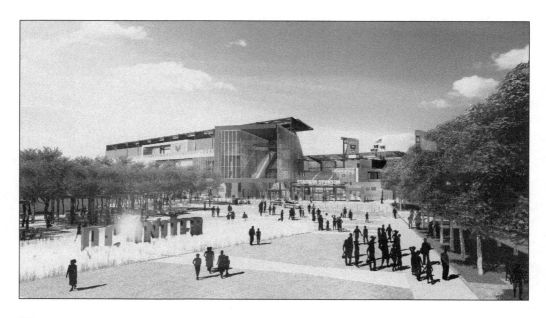

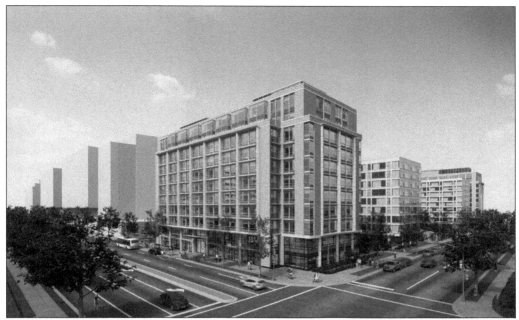

Ideally located in the heart of the Southwest Waterfront, 301 M Street is a 187-unit boutique apartment community opening in 2017. Located close to the Metro, the innovative transit-oriented development will let residents live, work, and play close to home. Maurice Walters Architect, PC, designed 301 M Street, with landscaping by Core Studio Design. The original adjacent 1960s buildings were designed by I.M. Pei. (Both, 3rd & M, LLC.)

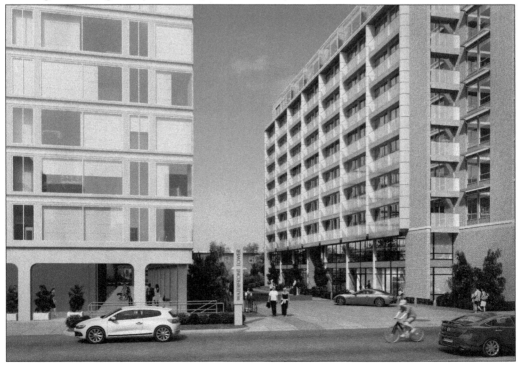

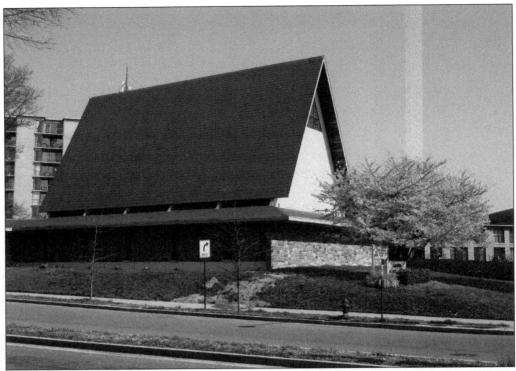

Riverside Baptist Church, located on I Street SW across from the Wharf project, is over 150 years old and has a long, storied history in Southwest. The church will be redeveloped as part of a mixed-use project that will include a new sanctuary, apartment building, and retail. (Authors' photograph.)

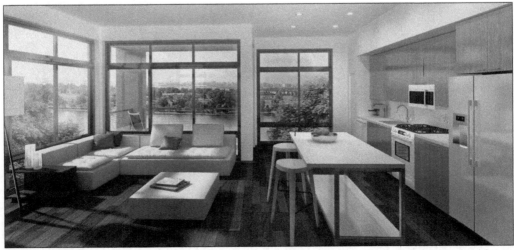

Southwest's current developments include many high-end, upscale condominium buildings, including 525 Water, a 108-unit, five-story building. Located close to the Wharf, residents will enjoy waterfront living and an array of restaurants and shops within walking distance. (The Wharf DC.)

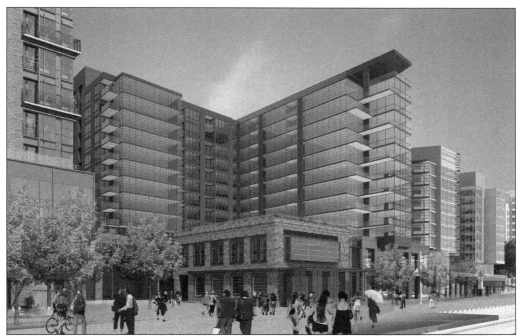

VIO, a 112-unit, 12-story luxury condominium building, will feature generously sized residences, including a mix of studio, one-bedroom, two-bedroom, three-bedroom, and penthouse units. VIO's amenities include a private lobby on the Wharf's Yacht Club Piazza with covered drop-off, 24-hour front-desk concierge services, clubroom, fitness center with yoga studio, and an outdoor infinity-edge pool overlooking the Potomac River. (Handel Architects.)

The influx of new residential projects being built has also spurred a number of national retailers to call Southwest DC home. The combination of a nearby Metro station, retail offerings, restaurants and shops, and diverse residential offerings allows residents to truly embrace the popular "live, work, play" lifestyle concept. (Authors' photograph.)

A large number of high-rise apartment buildings have recently been constructed in Southwest, including the Lex at Waterfront Station at 1151 Fourth Street (above and below). A rooftop deck with a heated infinity-edge pool, on-site fitness center, full-service concierge, and other amenities offer residents luxury apartment living that was not available in Southwest a few years ago. The adjacent Leo at Waterfront Station offers additional apartment options. The Lex and Leo buildings originally served as the headquarters of the US Environmental Protection Agency, and the buildings were gutted and rebuilt as apartments. (Above, photograph by Eric Burka; below, photograph by Garland Gay.)

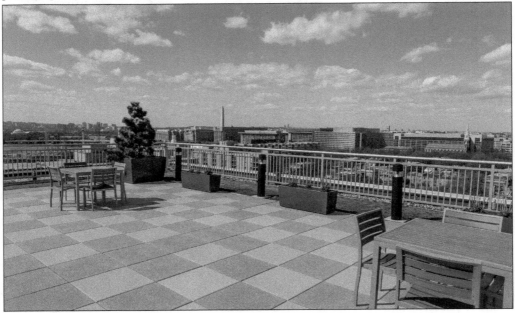

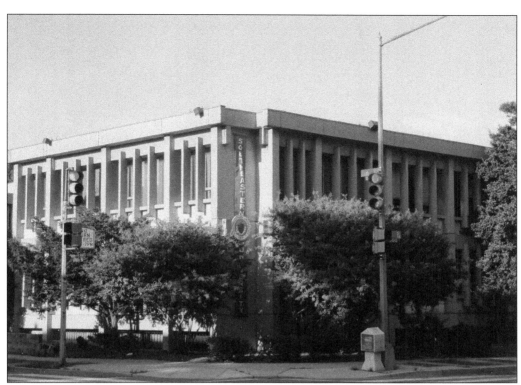

In 2009, Southeastern University lost its accreditation from the Middle States Commission on Higher Education after 130 years of service to low-income and international students. The small, private university, located at 501 I Street SW, permanently closed that year due to its small number of full-time faculty and low graduation rates. (Authors' photograph.)

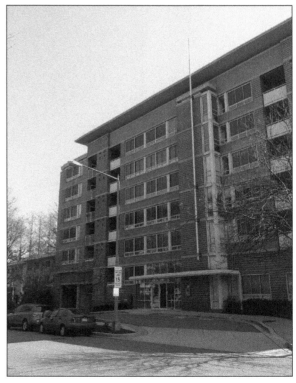

The Residence at Potomac Place was built in 2004 and designed by WDG Architects. It won 2004's Best New Washington Area Condo Infill Project. Located at 350 G and 355 I Streets SW, it was the first multifamily housing project to be completed in Southwest in decades. The two towers have 151 units each. (Authors' photograph.)

Visit us at
arcadiapublishing.com

...

Lightning Source UK Ltd.
Milton Keynes UK
UKHW052028081222
413639UK00003B/4